IMAGES
of America

AROUND
DELTA LAKE
LEE AND WESTERN

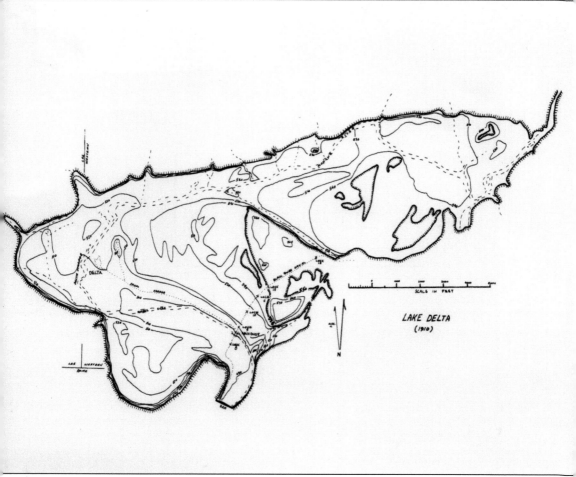

This map shows the layout of Delta Lake, covering areas in the towns of Lee and Western and touching the outside district of the city of Rome. The lake covers 4.8 square miles, including former farmland and forests. (Author's collection.)

ON THE COVER: A group of children from the Delta school has gathered for this undated school photograph. To mark the event, the children have dressed in their Sunday best. This interesting photograph provides a glimpse into their school life. The photograph, with the name Jennie on the back, must have been a family heirloom, for it was saved for future generations. (Author's collection.)

IMAGES
of America

AROUND
DELTA LAKE
LEE AND WESTERN

Mary J. Centro

ARCADIA
PUBLISHING

Published by Arcadia Publishing
Charleston, South Carolina

Printed in the United States of America

Library of Congress Control Number: 2013949112

For all general information, please contact Arcadia Publishing:
Telephone 843-853-2070
Fax 843-853-0044
E-mail sales@arcadiapublishing.com
For customer service and orders:
Toll-Free 1-888-313-2665

Visit us on the Internet at www.arcadiapublishing.com

*To our beloved dog Diamond, the blued girl, who
was the smartest dog one will ever meet.*

CONTENTS

ACKNOWLEDGMENTS

A thank-you goes to Tom Gates who is always willing to share images from his postcard collection. And thanks go to the many others who helped, including Mary June Pillmore who told of family life in the village of Delta with her many articles in the *Rome Sentinel* and with her diaries, which have been passed down in her family; and Virginia Ackerman, historian for the town of Lee, who shared the history of her town. Over afternoon coffee, Ernest Leigh and Doris Portner told me stories and shared photographs of the lumbering trade in the town of Lee. Old postcards found in the attic by Veronica Murphy show previously unseen photographs of the town of Western. At the Rome Historical Society helping me with my research were Mike Huchko and Ann Swanson. Dr. Russell Marriott shared his notes on Main Street in Westernville. The Engelbert family winter views of drained Main Street in Delta are priceless. Searching my family pictures, taken over the years on the shores of Delta Lake, I am able to show some of the fun times on the lake and some of the dry summers and falls we endured. Without the many articles in the *Rome Sentinel, Utica Globe, Boonville Herald,* and *Utica Observer,* this historian would not have been able to continue her research. Sincere thanks go to all of the above—for without their help this book would not be possible. It is an honor and a privilege to share the photographs and history of the town of Western, town of Lee, and Delta Lake with you. I also thank all my friends and family for their support with my first book, *The Lost Village of Delta,* and their continued support on this project. Unless otherwise noted, all images are from the author's collection.

INTRODUCTION

Delta Lake is woven into the fabric of the lives of those who reside in the towns of Western and Lee, which are situated on its shore. Having once made up a single township, both towns are steeped in history, dating back to the days following the Revolutionary War. A patent or land grant of 40,000 acres was awarded to Jellis Fonda that encompassed parts of both Lee and Western. The name Western came from the fact that the town is in the western portion of the original townships. Western's abundant water supply comes from the Mohawk River, Lansing Kill, Stringer Brook, and Wells Creek. The first settlers of Western were Asa Beckwith and Henry Wager who each took up 500 acres of land and established a homestead. Gen. William Floyd, a signer of the Declaration of Independence, built a large home on Main Street in Westernville in 1802. Jonathan Swan and George Brayton opened and operated the first general store for settlers and local Native Americans. The first official town board meeting for the combined towns was held in the home of the Sheldon brothers, who settled near the Mohawk River and the future site of the village of Delta on April 4, 1797. The inhabitants of the townships, using the only two pairs of oxen in the area, built the first bridge ever to across the Mohawk River. The town of Lee was named in honor of Lee, Massachusetts, the early settlers' home region. As more and more settlers came to the townships, many of them felt they needed their own town. The first official town board meeting for the town of Lee was held in March 1812. The township has numerous acres of good farmland while the northern part of the town is hilly, rising north of Stokes and Lee Center, along the northern boundary of Fonda's patent. The east branch of Fish Creek, west branch of the Mohawk River, Canada Creek, and West Creek provides a dependable water supply for Lee. In both townships, many villages and small hamlets sprang up near the abundant water sources. In early days, Delta was the principal settlement of the town but was flooded to make way for Delta Lake, which would supply water to the state's canal system. The seat of government was then moved to Lee Center. The shoreline of Delta Lake touches the townships of Western and Lee and a small section of the outside district of Rome. Many beautiful homes and camps now dot the landscape around the lake. Today, Delta Lake hosts one of the best state parks in the Northeast. Present-day residents of both townships share common interests and values. Families have intermingled in both the towns of Lee and Western and are descendants of the early settlers. *Around Delta Lake: Lee and Western* will highlight some of the history associated with the townships, along with many images of Delta Lake.

One

THE TOWN OF WESTERN

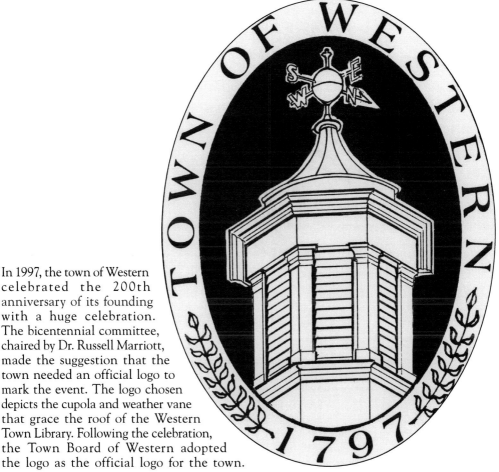

In 1997, the town of Western celebrated the 200th anniversary of its founding with a huge celebration. The bicentennial committee, chaired by Dr. Russell Marriott, made the suggestion that the town needed an official logo to mark the event. The logo chosen depicts the cupola and weather vane that grace the roof of the Western Town Library. Following the celebration, the Town Board of Western adopted the logo as the official logo for the town.

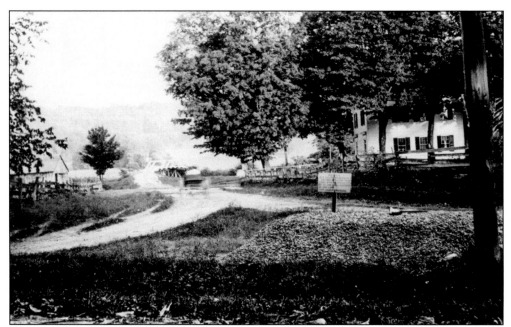

Shown is the intersection of the Gifford Hill Road and Main Street in Westernville. Just past the schoolhouse on the right, the road crossed over the Black River Canal via a bridge. The road then continued up and over Gifford Hill to South Hill. Today, this short street passes the new post office, where the schoolhouse was once located, and it crosses an improved highway before going up the hill.

This is a southerly view of Main Street in Westernville. In the distance can be seen the white two-story schoolhouse, and beyond it are lovely hills that surround the village. In the 1940s, at the intersection of Main Street and Gifford Hill Road, a firehouse was built. In the open space, a convenience store now exists.

10

Dr. Chester Gaylord constructed this Federal-style home on the east side of Main Street in Westernville around 1815. The two-story home with gable ends facing the street was a popular style of that era. On the north side, a small wing was added and used as a physician's office.

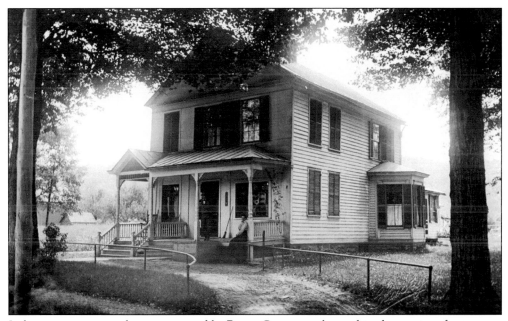

In later years, a general store, operated by Byron Crego, was located in the spacious front room. A butcher shop was located in the former physician's office. At one point in time, the home had two front doors, one for entrance to the store and the other to the home. The home has been converted into a one-family dwelling.

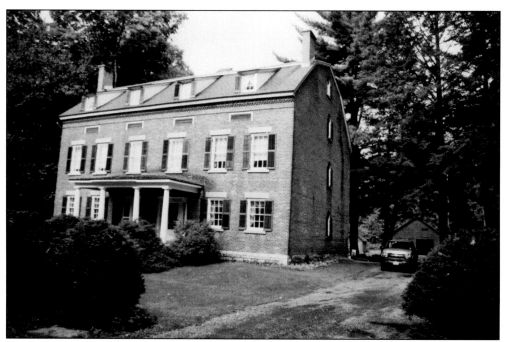

This handsome Dutch-style brick home, with a gamble roofline and dormers, is located on the west side of Main Street. William Floyd Jr. built the house in 1854. It was constructed as a two-family dwelling with two front doors and two staircases, but with only one kitchen. In later years, it was the home of C. Frank Floyd.

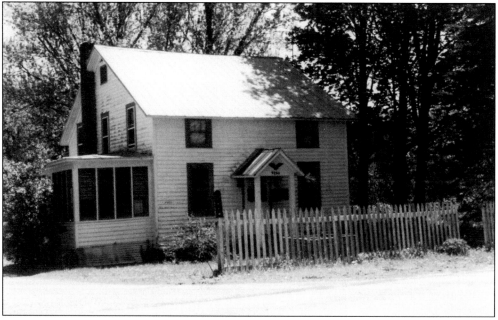

Located at the north end of Main Street, this home was originally a lock house on the Black River Canal. It was located on the east bank of the canal and was moved across the canal to its present location when canal use was discontinued. Over the years, it has evolved into a lovely country home.

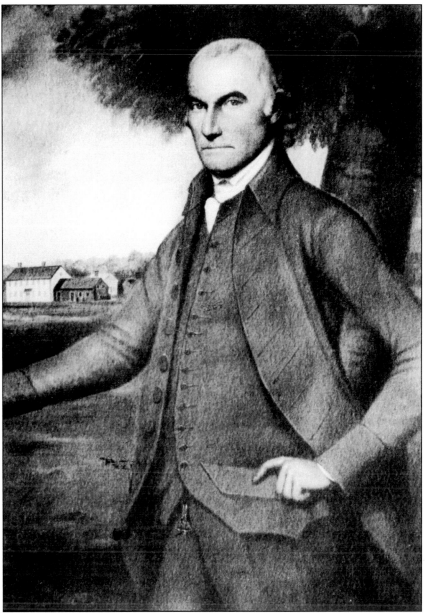

Gen. William Floyd was one of the youngest signers of the Declaration of Independence. His ancestors of Welch descent were among the early settlers of Suffolk County on Long Island, New York. William inherited the family estate at Mastic Beach, Long Island, in 1752 when his father died. He became a wealthy landowner with excellent connections and achieved an increasing role in politics of the era. William represented Suffolk County in the First and Second Congress in 1794 and 1795. He was in Philadelphia when the Provincial Congress approved the Declaration of Independence, and he signed the document on August 2, 1776. During the Revolutionary War, he obtained the rank of major general in the Long Island Militia. In January 1786, General Floyd purchased 10,000 acres of land in the town of Western. In 1802, he built a large home on Main Street, where he spent the remaining years of his life. General Floyd passed away in 1822 and was buried in nearby Westernville Cemetery.

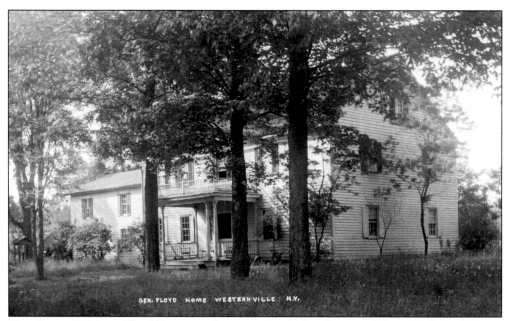

The General William Floyd House on the west side of Main Street in Westernville is the most historic property in the town. The Georgian-style home was designed by General Floyd to mirror his ancestral home on Long Island, New York. The home has the classic center hallway, a dining room to the left and a parlor to the right. The door at the end of the hallway admitted farmers to the farm office in the rear.

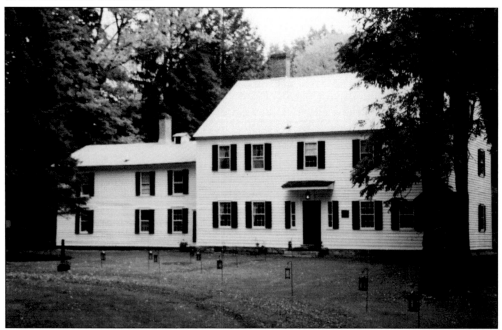

Over the years, the General William Floyd House passed down through the Floyd family and fell out of use. In the late 1940s, the home was sold and changed hands several times. A local dentist purchased the home and has restored it to its former glory. In 1971, the General William Floyd House was placed in the National Register of Historic Places.

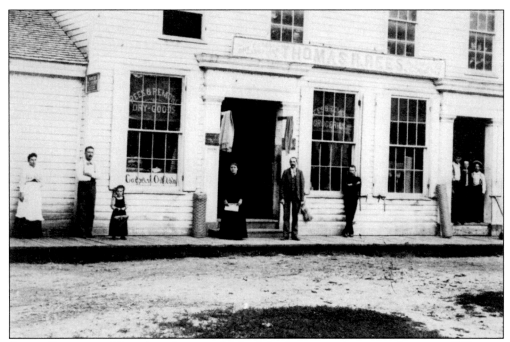

George Brayton and Jonathan Swan established the first general store in the town of Western. The Brayton-Swan general store was an important stop for the locals and others traveling through town. The store did a good trade with the local Native Americans. Mail was delivered once a week there. As time passed, other general stores sprang up in town.

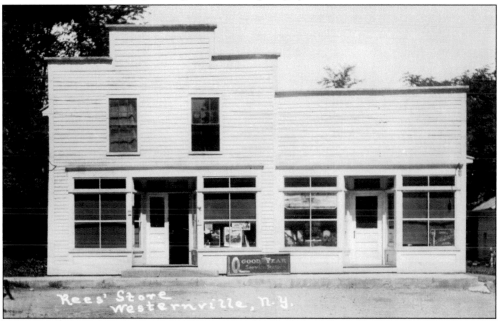

A popular store at the south end of Main Street was the Rees store. After the store burned in May 1918, Cora Jones bought the property and moved her store, Jones general store, to the site and enlarged the building. In later years, Roy Pillmore, Lyle Traxel, and Donald Sexton operated the store. For many years, the building housed the local post office. (Courtesy of Tom Gates.)

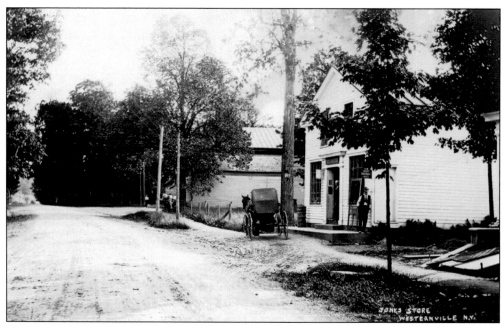

Here is the Jones general store, owned by Cora Jones, on Main Street in Westernville. It was a little store that carried the merchandise of the era. This is the building that was moved to the site of the former Rees store.

A new generation of general stores, now called convenience stores, has evolved over the past 20 years. Offering early-morning coffee and a quick fill-up on gas, these stores have become very popular. The convenience store in Westernville is the only one of its kind between Delta Lake State Park and Boonville.

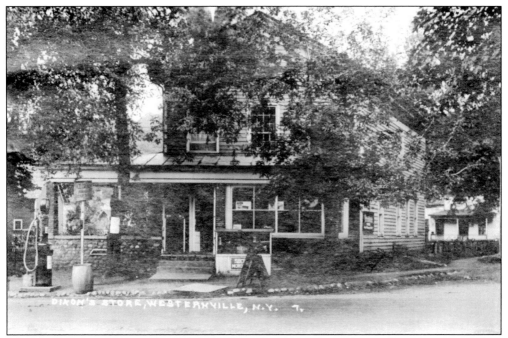

The old Dixon store, later the Dabrowski/Capron store, sat on the northeast corner of Main Street and Dopp Hill Road. The store was built in 1847 at a slant to conform to the angle of the road. In the 1930s and 1940s, the locals considered the store the town hall. Between Rome and Boonville, this was the only store that had gas pumps.

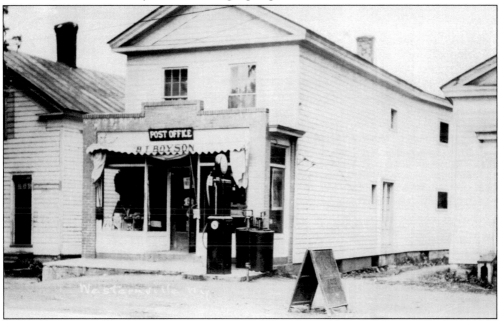

Burt Boyson's store on the east side of Main Street in Westernville was a novelty five-and-dime store. At one point in time, the local post office was located in this store. Oscar Anken took over the store and operated it until the 1950s. For a short time, the store also had gas pumps for passing motorists. The building is now a private home.

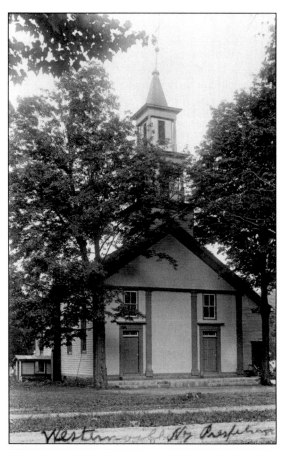

The Friends Society built this church building in 1818. It was a Union church to be used individually by the Baptists, Methodists, and Presbyterians. In the early 1830s, the Presbyterians took responsibility for the church. Alterations and renovations have occurred over the years for better use of the building. The church is a landmark in the community, with an active congregation. It is officially known as the First Presbyterian Church of Westernville.

The Presbyterian church manse is located on the west side of Main Street and is the home of the resident minister. The structure with a board-and-batten exterior siding was built around 1840. The home is still in use as the residence for the Presbyterian minister. (Courtesy of Veronica Murphy.)

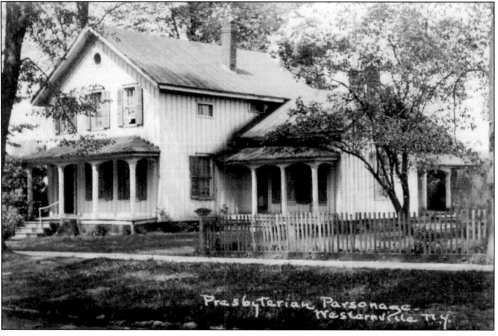

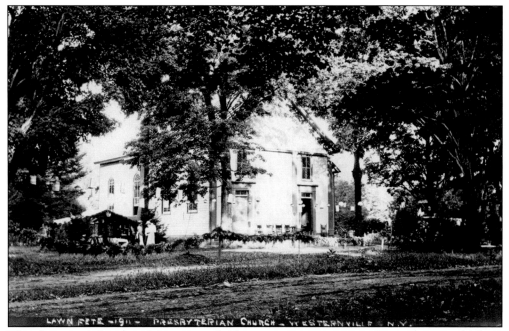

This photograph shows a celebration, probably a summer ice cream social, in progress on the front lawn of the Presbyterian church. Members of the church were active in its various organizations. These groups raised funds by hosting annual church suppers, ice cream socials, quilt raffles, and bake sales.

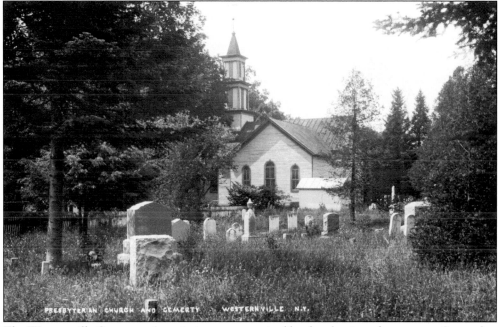

The Westernville Cemetery Association was organized by the election of trustees on September 7, 1868. Gideon Hawkins gave a half acre of land as a place for burials in Westernville. This multiple-acre cemetery has evolved into a beautiful resting place for loved ones. (Courtesy of Celesta Centro.)

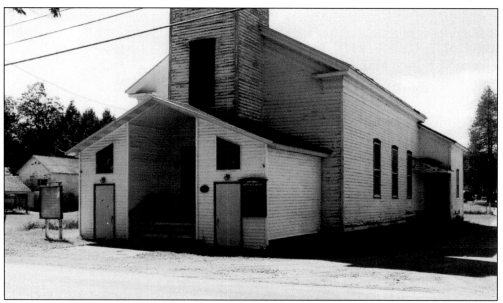

Members of the Methodist faith in 1852 purchased land from Calvin Church and built their house of worship. A nice white clapboard structure with a bell tower and stained-glass windows was erected. Some original pews, chairs, and alter railing and the original pulpit are still in place. Sadly, the church is no longer in use and has been closed. (Courtesy of Veronica Murphy.)

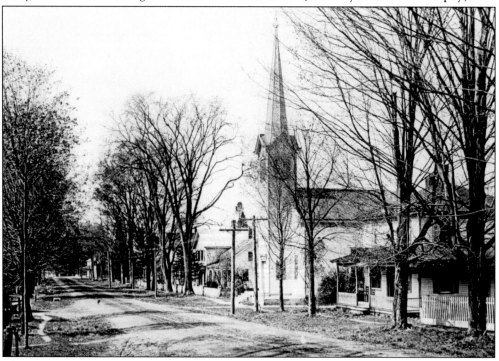

The stately Methodist church occupies a prominent place on upper Main Street. It is a local landmark, and for years, it was where Old Home Days was hosted where church members could share old memories and make new ones. The church is located on the east side of the Westernville Cemetery.

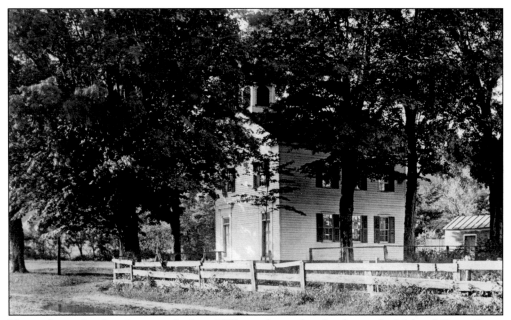

The earliest school in the town, built in 1802, was located on land near the Mohawk River. Prior, to that, a log cabin school was constructed near the village of Delta with slab seats and a stick chimney. Another school was located near the Henry Wager estate.

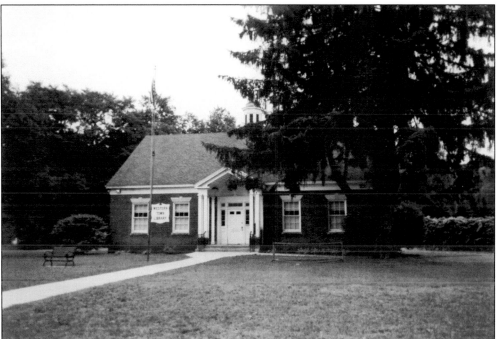

In 1878, a two-story wood-frame building was erected on the lower end of Gifford Hill Road. The first-floor classroom was for the lower grades with the second floor for students up to the eighth grade. In 1941, a new brick schoolhouse was erected just west of the old school. When the City of Rome consolidated all school districts into one system, local children were bussed to schools in Rome. This building is now the town library.

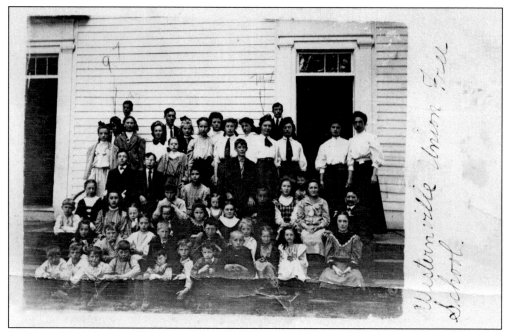

In front of the Westernville Union Free School, a group gathers to have an annual picture taken. Some of the teachers were Leanora VanWagenen, Ida Sloat, and Minnie Davis, among others. Many of the children lived close and could walk to school. (Courtesy of Marjorie Warcup.)

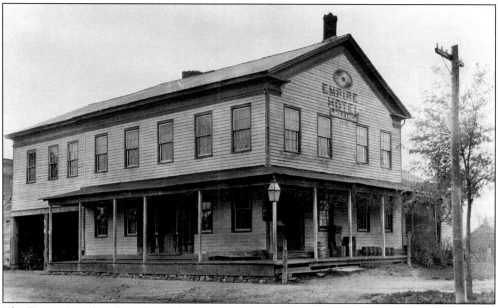

The Empire Hotel in the village of Delta was built in the 1840s. It was a large wooden structure with a wide wraparound porch. The hotel was the stagecoach stop, as the stage passed through twice a day bringing goods and mail. When the land was taken by the state for canal purposes, the building was sold to a group of investors from Westernville.

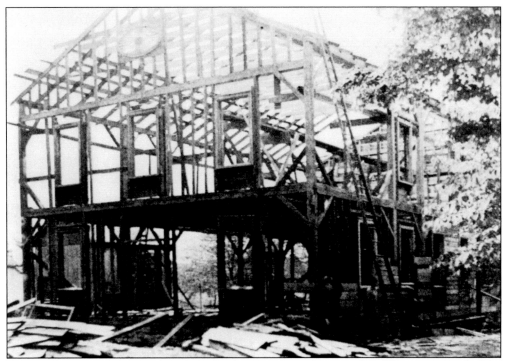

The old hotel was dismantled, and the lumber, windows, doors, and moldings were marked for reassembly. Horses and wagons then moved the pieces over the old River Road via Kettle Hill to its present location on Main Street in Westernville.

The old Empire Hotel was renamed Liberty Hall in honor of Gen. William Floyd. The building was redesigned with two large rooms downstairs, a kitchen, bathrooms, and storage area. At different points in time, the post office and library were both located in the hall. The hall became the social hub for the township.

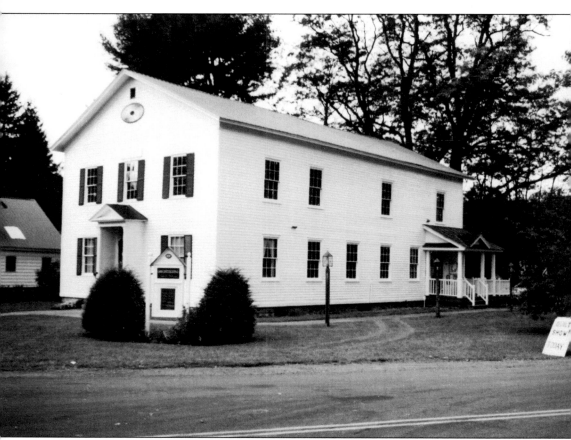

In 1960, the town of Western purchased the building. The old hall became the seat of government for the town. The building houses the offices of the town clerk and town justice. The two large meeting rooms downstairs serve the town board, planning board, and zoning board of appeals. The senior citizens, Boy Scouts, and 4-H members meet here on a regular basis. Upstairs is a large auditorium with a stage. Square dances were held upstairs Saturday evenings. Many local residents performed in an annual talent show with the town chorus. In 1995, through the efforts of the Town of Western Historical Society, the old Empire Hotel, renamed Liberty Hall and now the town hall, was placed in the National Register of Historical Places, thus recognizing its historical significance.

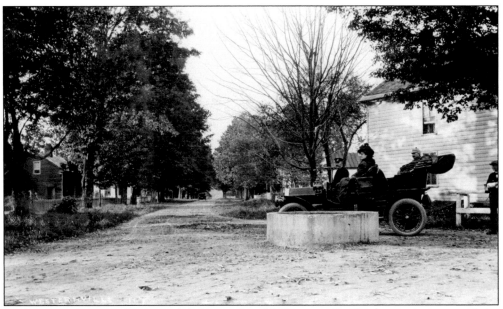

A chauffeur-driven early automobile leaves the old Westernville Hotel on a drive around the town and then on to Lee Center. The car could have been the electric auto owned by Margaret Pillmore, a local resident of Westernville. (Courtesy of Tom Gates.)

Early in the morning, the Rome-to-Western stage left Rome, from White's Hotel, traveling the old stage route to Westernville. Then, it went on to North Western, stopping at Alonzo Davis store to deliver the mail and goods. The stage was always a welcome sight.

Henry Wager was one of the earliest settlers of the town of Western, coming here around 1789, at the age of 25. He took up 500 acres of land and built a home. His farm was one of the best in the area, with many fine improvements. He held the position of town supervisor for over 25 years. Wager lived on the homestead for more than 50 years until his death.

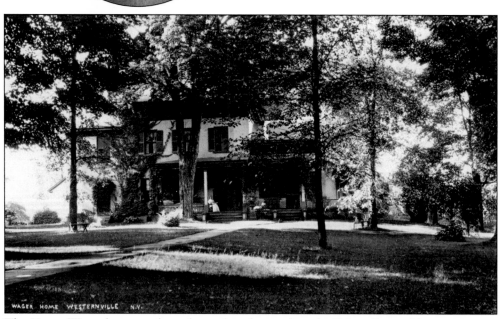

The Henry Wager homestead was located at the south end of Main Street. No expense was spared when the mansion was built with exotic woods, stained glass, copper, and brass. The seven marble fireplaces, with mantels cut from local wood, heated the main rooms. When the state took the land for canal purposes, George Olney Sr. purchased the house and had it dismantled; the materials were saved to be used in a home he was building.

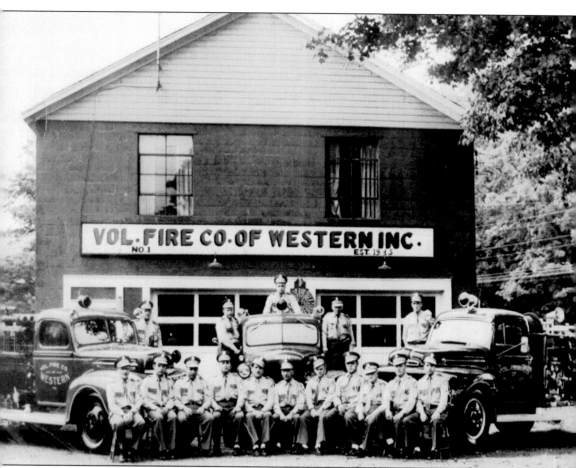

The Volunteer Fire Company of Western was founded in 1945. The need for a fire company came to the forefront due to a disastrous fire in the village of North Western. Monies were donated and loaned by many generous citizens to finance a firehouse and equipment. Before the firehouse was completed, the new fire truck was kept in the barn of John Ellis. Pictured in front of the new firehouse and truck are, from left to right, (first row) Clarence Cummins, Jack Pelton, Bob Knutti, Ted Pillmore, Harold LeClair, Ed Knutti, Sherwood Waterman, Frank O'Brien, Gan VanLoon, Forrest Wollaber Jr., and Elmer Holmes; (second row) Roy Jones, Wiley Pelton, Harvey Hawkins, Lynn Griffiths, and George Franz. (Courtesy of David Teller.)

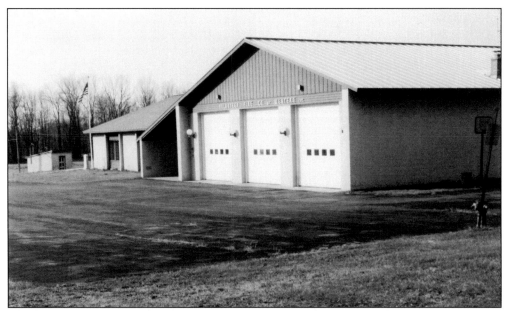

In the 1970s, the Western Fire Company bought land north of the village, and in 1980, a state-of-the-art building to house the fire equipment was constructed. The building has a large meeting hall, kitchen, and adequate space for the trucks. Later, in 1993, the company closed the firehouse in North Western, having all its equipment in one location.

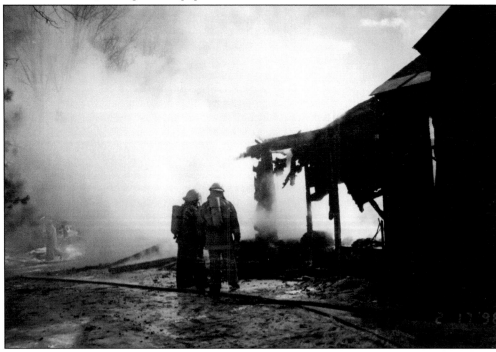

The Western Fire Company has two pumpers, two tankers, a brush truck for forest fires, light-duty rescue truck, and heavy-duty rescue truck. The company also owns a hovercraft and boat. On staff are several advanced life support technicians. Seen are members mopping up after a residential fire.

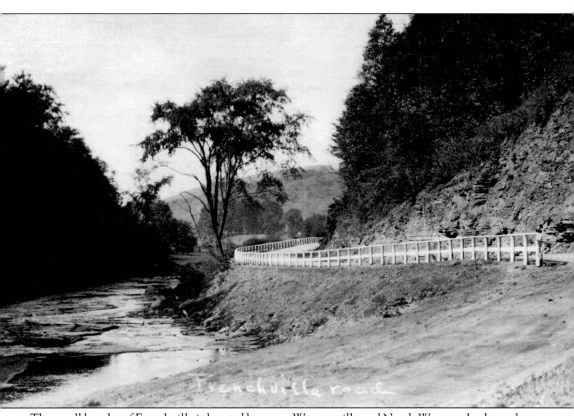

Frenchville road

The small hamlet of Frenchville is located between Westernville and North Western. In the early days, David French owned most of the farmland in the area, and the small hamlet was named for him. The hamlet supported a general store, shoe peg factory, sawmill, barrel tub shop, and a limekiln. During the days of the Black River Canal, a shipping point was opened, where goods could be shipped. Just pass the hamlet, on the right, is the beautiful, winding Frenchville Gorge that follows Wells Creek through the hills toward the town of Steuben. Today, only two road signs mark the hamlet, and as people travel through the area, they do not realize that it was once a prosperous thriving hamlet.

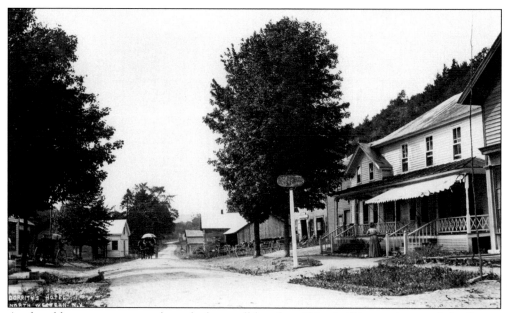

As the old stage route went through the small hamlet of North Western, it passed the former Northern Hotel, later called the Dorrity Hotel. The hotel specialized in chicken dinners for $1. The Black River Canal ran behind the building, which was a popular stop with travelers on the canal.

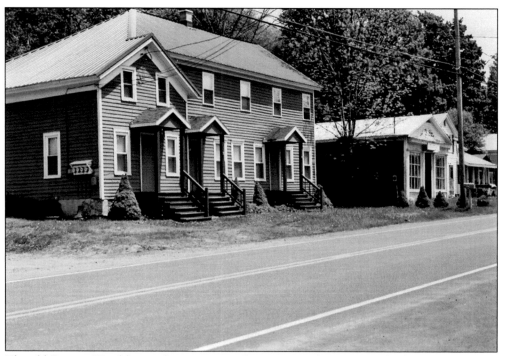

The old Dorrity Hotel has undergone many changes over the years. In the last few years, the building has been converted into four apartments and has received a face-lift with nice vinyl siding and some landscaping.

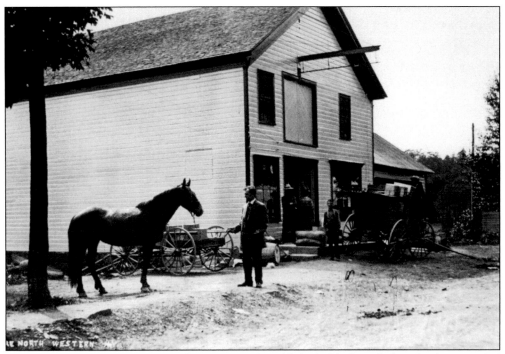

In 1890, Alonzo Davis came to North Western and established a blacksmith shop that he expanded into a general store. The store became known as the W.B. Davis & Sons General Store. A favorite item carried was New York State Extra Sharp Cheddar Cheese. After the deaths of Russell and Arlene Davis, the store closed.

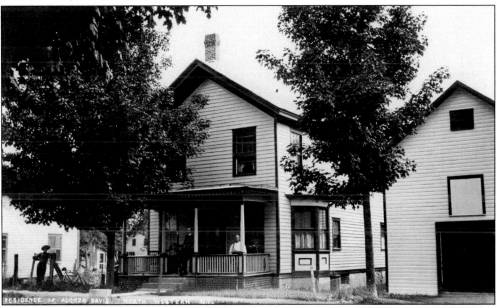

Next to the general store was the home of Russell Davis and his family. A wide front porch graced the home, giving it a nice comfortable look. It appears to be a nice home, which was a landmark in North Western. The family might have spent many evenings visiting with neighbors and store customers while sitting on this porch.

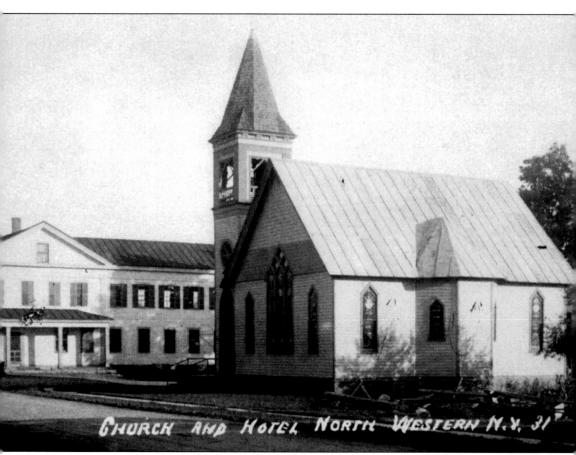

Church and Hotel North Western N.Y. 31

The Methodist church in North Western was built in 1839 and burned in January 1898. The congregation raised the funds to build a new church that was in use by December 1898. The church continues to serve the religious needs of the area. David Brill built the Half-way House in North Western in 1852 to replace one that had burned. The hotel was called the Half-way House because it was located halfway on the old state route between Rome and Boonville. Located across the street from the Black River Canal, it served travelers on the canal.

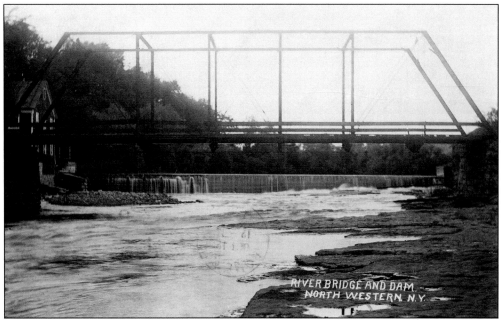

On the Mohawk River in North Western beside this old milldam, Charles Pillmore built an electric power plant in the early 1900s. A single power line was run from the plant to his feed mill in Westernville. Soon, the local residents were purchasing electricity from him, with the power only available in the evenings. Pillmore supplied the power for the electric car that his mother, Margaret, owned.

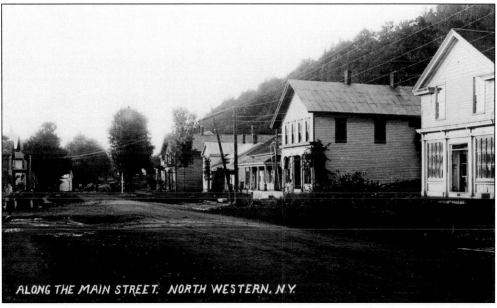

This is another nice street scene in North Western. In the foreground is Barnard Hall, which was used by the Methodist congregation for its harvest dinners. At one point, it was the voting site for the people in that part of town. The second story of the building has been removed for safety reasons. The structure is not in use today.

On the Tannery Road near North Western was an old tannery that was later used as a sawmill. The small stream in the nearby hills supplied water for the mill, and the abundant trees supplied the mill with lumber, some of which was used by residents and some shipped down the Black River Canal. In later years, Will Yutzler ran the mill.

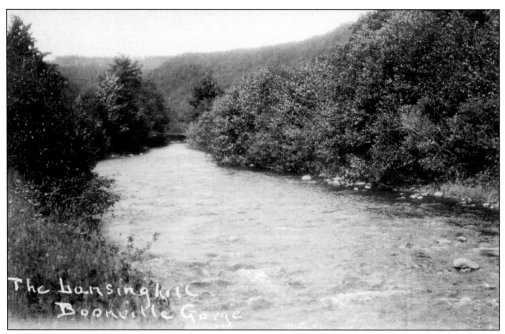

Just beyond North Western is the beginning of the Boonville Gorge. The Lansing Kill has carved out the rocks and shale over the millions of years to form this impressive stream. In the steep hills, the Lansing Kill begins twisting and turning on its way to where it joins the Mohawk River at Hillside. (Courtesy of Veronica Murphy.)

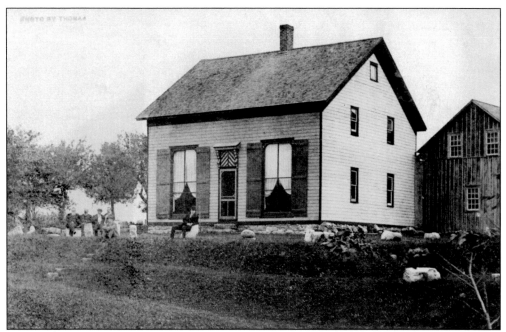

Boody Hill, a tiny area at the top of a winding gravel road in the hills surrounding the town, was named in honor of Jacob Boody, a Renaissance man and freethinker. Born in 1839, Jacob went on to become a farmer, taxidermist, and sculptor. He carved more than 100 elaborate stone carvings of biblical themes, presidents, and animals. (Courtesy of Tom Gates.)

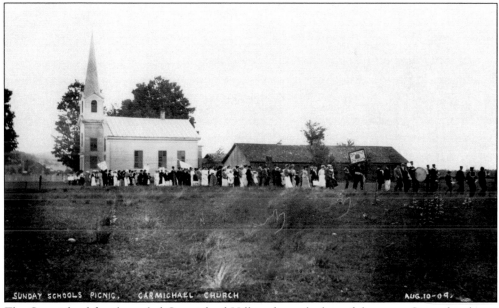

The Carmichael family settled Carmichael Hill in the early days of the town. Since the closest church was at North Western, a Methodist church was built on the hill. In 1840, land was set aside for a cemetery. A Sunday school picnic, complete with a parade and marching band, is shown here. The church fell into disrepair and has been torn down.

Hillside is a small hamlet located where Stringer Brook joins the Mohawk River. The settlement was originally called Leila, but in later years, the name was changed. In its heyday, the hamlet supported a general store, feed mill, sawmill, and school. The stage to Boonville stopped at the general store daily. When the new state road was constructed, the hamlet was bypassed.

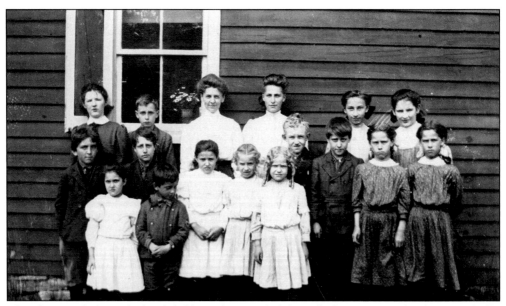

This photograph shows the local children who attended the Hillside one-room school in 1918. Sadly, no names are noted on the back. In the group, there are two sets of twins, boys on the left and girls, dressed alike, on the right. The small clapboard building was heated with a wood-burning stove and must have been chilly on those zero-degree days of winter. (Courtesy of Marjorie Warcup.)

The old iron bridge is now gone, and the ancient road that ran from Hillside through Cahootus Hollow and up through the hills is overgrown. The road was rough and wound its way among the rocks and brush. Used as a shortcut, the road was once busy but was used less as time went on. The gorge was so narrow that the sun seldom shown there. The steep hills and poor soil made farming difficult. Cahootus Hollow was the home to 10 families known for their clannishness. Families were large, and some of the men worked on the Black River Canal to support them. Cahootus Hollow got its name from a nickname the men were called. Some of them were not ambitious and slow to work, and so, farmers would call, "Hey, you cahoots," get to work.

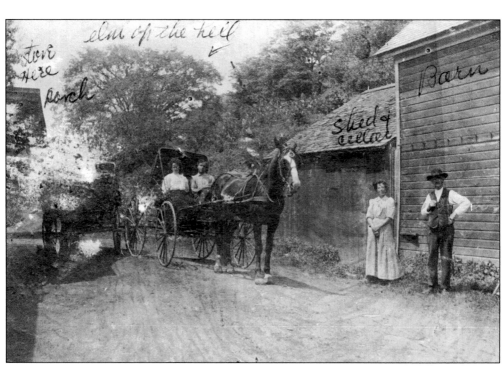

Dunn Brook was a tiny settlement on the old stage route to Boonville. The small population was able to support T.J. Race's general store and a nearby one-room schoolhouse. Grace and Wilbur Rogers are seated in the buggy, with Mary Race and Charles Campbell standing by the road. This settlement was also bypassed when the new state road was constructed. (Courtesy of Marjorie Warcup.)

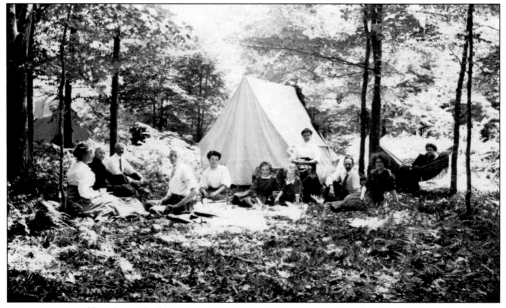

Here, a group of local people, known as VanArnam's Scamps, enjoys hiking and camping in the Dunn Brook area. The leader of the group is sitting under the tree in a white shirt and tie. They are camping complete with tents, hammocks, and portable chairs.

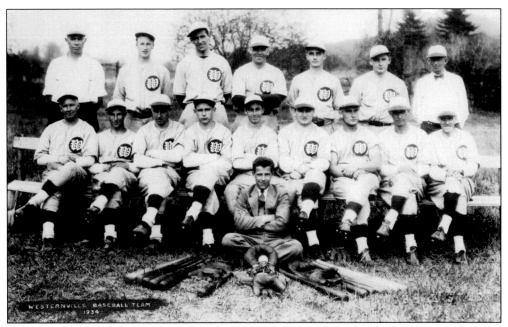

Baseball, the great American pastime, was very popular in the townships of the county. This 1934 picture shows the Westernville home team. According to newspaper accounts, the team played the teams of Lee Center, Taberg, Floyd, and others. The team was very successful in pursuit of local baseball dominance.

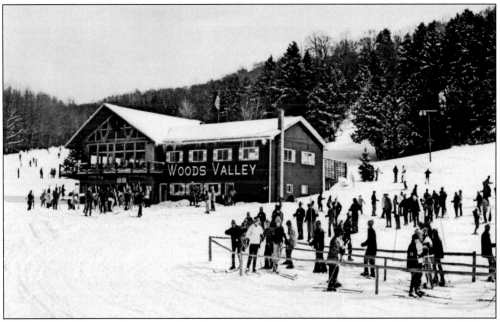

Woods Valley Ski area first opened in the winter of 1964, with a 2,200-foot T-bar and a 500-foot rope tow on a 400-foot vertical rise on Dopp Hill near Westernville. The snowfall that first winter was below normal; Dave Woods was encouraged by the turnout and support of skiers. On this hill in the 1940s, locals skied and were towed up the hill by a single rope tow driven by an old Model T engine used on the single ski run.

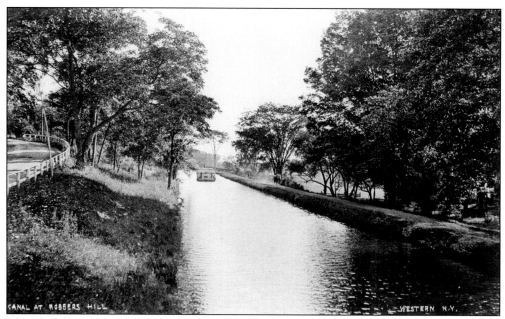

The Black River Canal that starts in Rome traveled through the town of Western on its way north. The canal brought prosperity to the small hamlets along its route. Farmers could now ship their produce and dairy products both north and south. Boatloads of lumber could be moved to available markets.

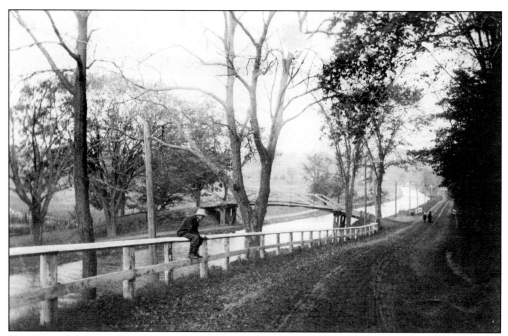

Sitting on the fence at Robbers Hill, near the Black River Canal, is George Spink Jr. Folklore tells that the hill got its name because canal boats and stages were robbed at this location. It is possible that the infamous Loomis Gang operated along this route and hid in the surrounding hills.

Two

THE TOWN OF LEE

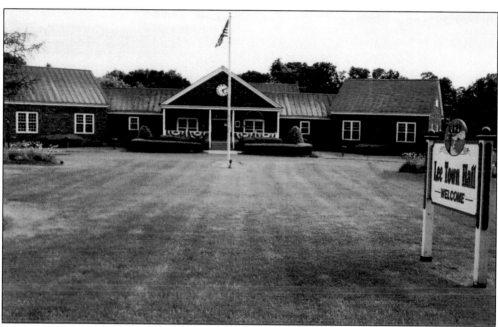

With more and more people coming to the town of Western to settle the land, many of them felt the need to become their own township. The town of Lee was separated from the town of Western in 1811, with the first town board meeting held on March 3, 1812. History tells that the first frame building erected in the town was southeast of Lee Center in the vicinity of Hawkins Corners. For over 20 years, church services, school, and town business was conducted from the building. In 1991, a new multifunction town hall was constructed. Located in the stately brick structure are town offices, a courtroom, a large meeting room, and a large basement storage area. Many seminars and meetings are held in the building and are sponsored by local governments. Surrounded by spacious lawns and gardens, the building has become a landmark in the town.

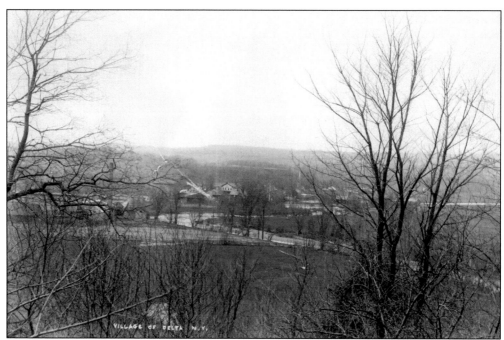

The Sheldon brothers settled near the future site of the village of Delta on the west bank of the Mohawk River around 1790. Here is the famous bend in the river that gave Delta its name. According to popular folklore, Capt. Gates Peck said if a person drew a line across the bend while standing on top of the hill, the shape was the letter D, which is "delta" in Greek.

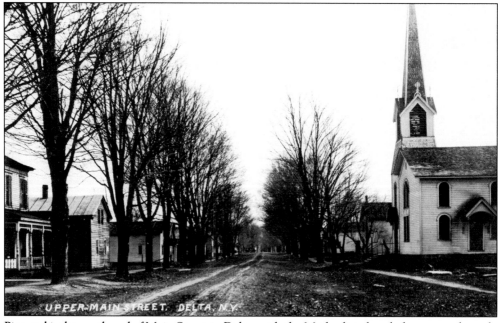

Pictured is the north end of Main Street in Delta, with the Methodist church, homes, and stately old trees. Israel Stark, an early settlers and landowner, laid out the village in a neat and orderly fashion, with residential lots all about the same size. An area was laid out for the manufacturing mills on the Mohawk River.

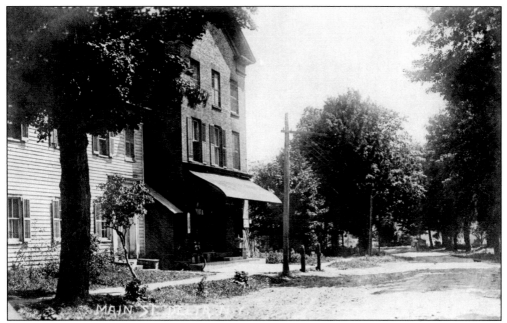

One of the most unique buildings in Delta was the three-story brick block erected in 1834 from bricks burned on the Mohawk River flats. An impressive building, it was constructed with two tiers of bricks on the outside walls. On the first floor was the general store, owned and operated by Frank and Lottie Harrington. Living quarters were on the second floor, and the third floor was used for lodge rooms.

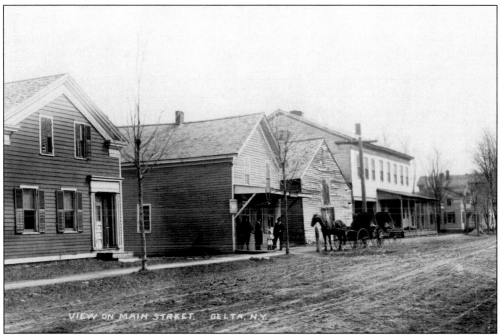

A smaller general store located on Main Street in Delta was the John Ernst store, built in the 1840s. The store carried the general merchandise of the era, along with shovels, brooms, and leather goods. On the counter inside the store was a jar of hard candy that John Ernst gave to children.

The second oldest cheese factory in the United States was built in Delta. In 1863, the farmers from the towns of Lee and Western formed a cooperative and began to manufacture American cheese. After three years, the cooperative dissolved, and the buildings were sold. Cheese continued to be manufactured there for many years.

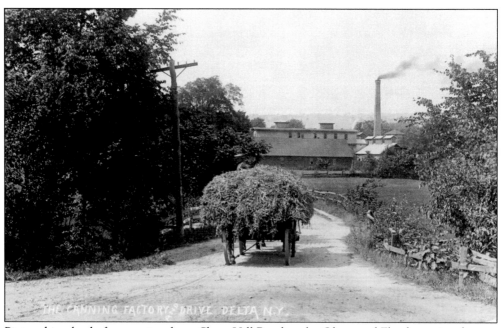

Pictured is a load of peas going down Short Hill Road to the Olney and Floyd canning factory. In 1884, C. Frank Floyd and George J. Olney Sr. owned the complex and operated it until the land was taken by the state. The canning factory was well organized with a main cannery and outbuildings.

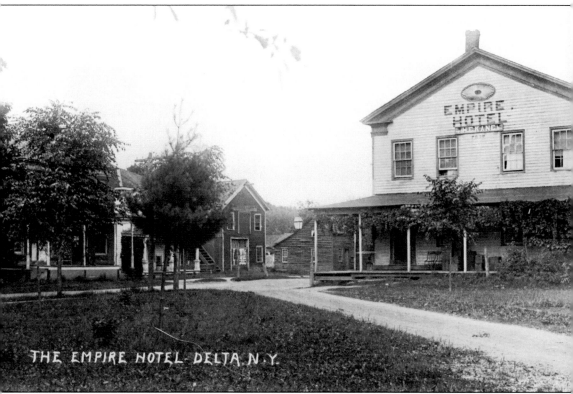

THE EMPIRE HOTEL- DELTA N.Y.

The Empire Hotel, located on Main Street in Delta, was the local hotel and stagecoach stop. The stage brought the mail, goods, and visitors into the village. The building was constructed around the late 1840s or early 1850s. The hotel had a kitchen wing, bar room, ladies' parlor, upstairs bedrooms, and a wide porch. Local folklore says there was a ballroom upstairs, but it probably was located over the carriage barn, as was the style of the era. The village green was across from the hotel. The green was a place where people could meet and the children could play. For Fourth of July, locals held a celebration there with the raising of a liberty pole with cannon salutes. A large picnic was held, and the day came to a close with Jay Smith's band playing patriotic tunes. (Courtesy of Tom Gates.)

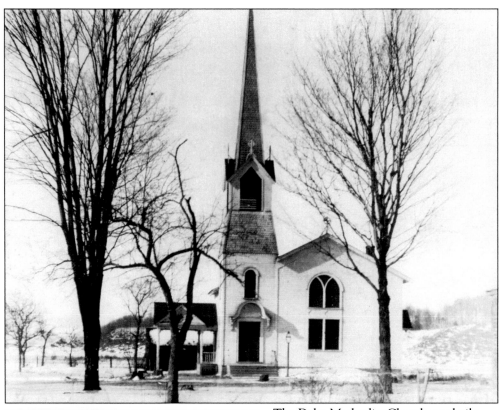

The Delta Methodist Church was built in 1843 and remodeled in 1883. At that time, a new 1,500-pound bell was placed in the steeple. The vestibule door was on the south side with a covered porch. The main church entrance faced Main Street. Inside was a lovely auditorium with stained-glass windows, a good organ, red pew cushions, and a grand pulpit.

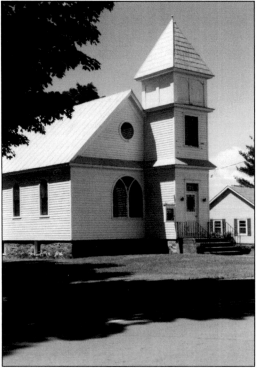

A group of individuals from the Blossvale area purchased the church and had it moved to a location there. The building was dismantled and moved by horse and wagon. In rebuilding the chapel, the group used the beams, siding, doors, windows, and big cathedral window in the new place of worship.

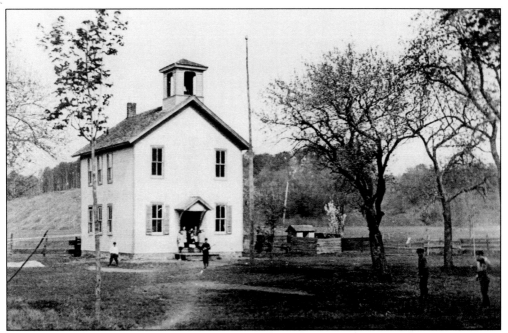

The Delta school was located at the north end of Main Street, an ideal location for a school with a spacious playground and lawns sweeping back to the hills. The first floor was for the younger students, with the second floor for the older and more advanced students. The building was erected in the 1850s to replace the brick one-room schoolhouse.

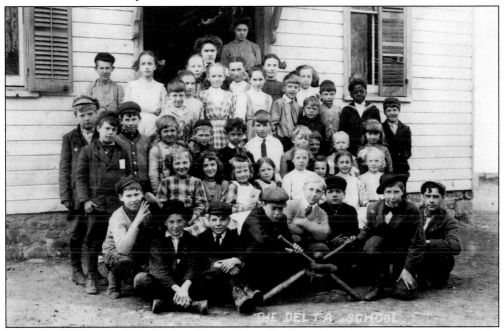

Children from the Delta school gather on the school steps for their annual picture. On the playground, the boys often played baseball while the girls played ring-around-the-rosie or tag. Pictured holding the baseball bat is Ernest Portner with his brother Albert Portner. (Courtesy of Ernest Leigh and Doris Portner.)

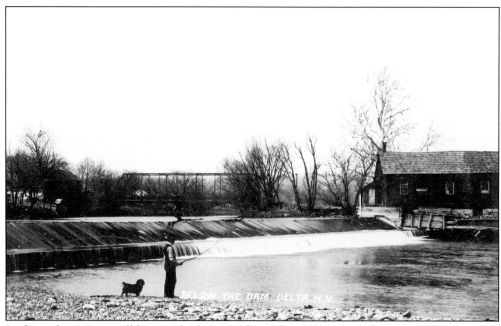

In the early 1800s, a milldam was built across the Mohawk River at Delta to form a millpond to operate the nearby mills of Judge Prosper Rudd. Anson Dart rebuilt the milldam in the 1830s by improving the dam with laying limestone blocks set in place with heated lead. John Ernst and his dog Buster are fishing at the foot of the dam.

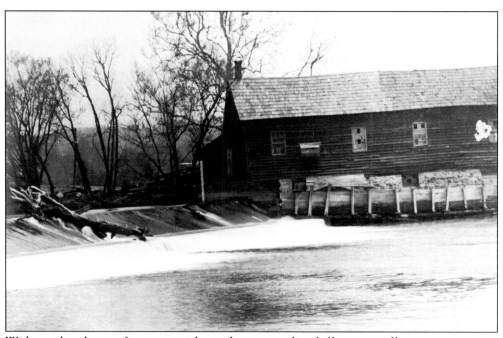

With an abundance of raw materials on the surrounding hills, a sawmill was an important business in the early days. David Smith and his sons built the first mill in the valley on the west side of the Mohawk River. The mill ran continuously, turning out lumber for the new homes and businesses.

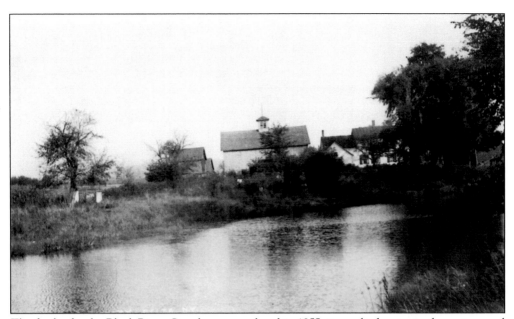

The feeder for the Black River Canal was completed in 1855; it supplied water to the main canal about half mile away across the valley. Canned goods from the local factory could be shipped north and south. Cobblestones, which were used in the paving of the streets of New York City, were shipped down the canal, among other items. (Courtesy of Sylvia Kahler.)

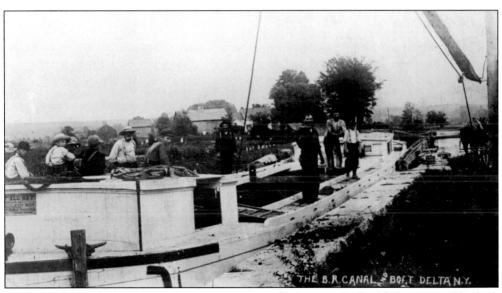

At the end of the Black River Canal feeder was a lock, near the Rudd Cemetery. The lock controlled the amount of water allowed to flow from the Mohawk River at Delta to the main canal. Pictured are Fred Beckley and his sons Charles and Fred Jr. unloading coal from the canal boat for a nearby coal shed.

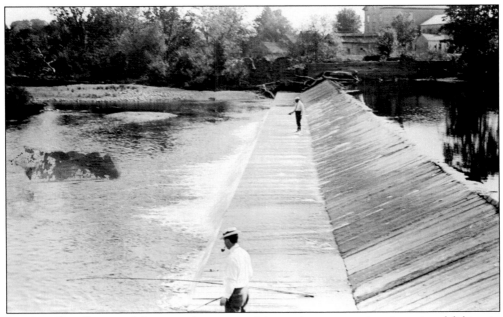

On their day off, some of the men who were working at the construction site enjoyed fishing in Mohawk River, near the milldam. It must have been late in the summer, for there does not seem much water going over the dam. In the background can be seen the brick block.

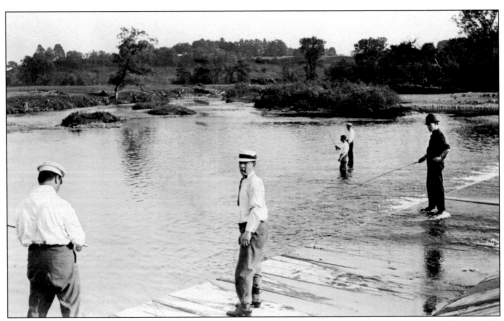

These men seem to like having their picture taken while fishing by the milldam. Folklore tells that the dam was not completely destroyed when the state took the land, and it existed under the water for many years. Finally, over the years, the remnants of the dam washed away.

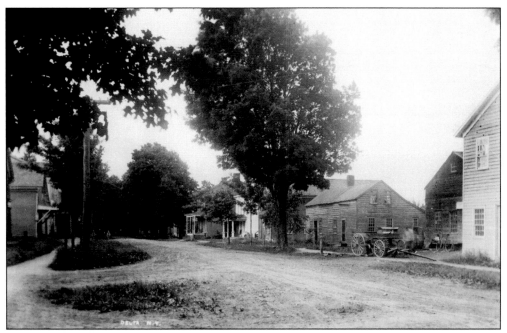

Traveling down Main Street in Delta, one passed the McIntosh brothers blacksmith shop. The brothers operated their business in the village for more than 30 years. Richard McIntosh made the finest sleighs and wagons in the area, and George McIntosh was the blacksmith. They supplied the needs of local farmers.

This peaceful scene shows Main Street. The brick block is in the foreground with the lovely homes in the distance. The street is lined with graceful old maples. In a few years, this scene will be gone. In 1910, the state began to take the village land to create a reservoir for New York State Barge Canal purposes. By 1916, the village lands and surrounding farmland were under water.

A lovely country road lined with flowing apple trees must have created a most pleasant spring drive. Townspeople and farm folks were known to travel about to visit family and friends. In the winter, they managed to travel the rutted and muddy roads with little difficulty.

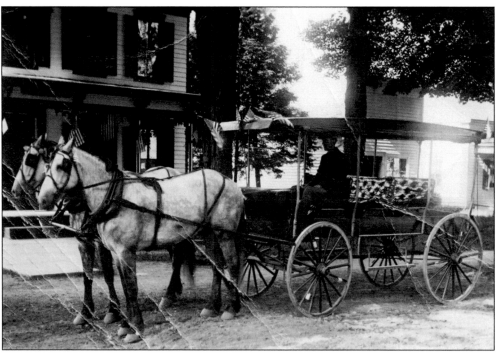

This surrey with fringe on the top and American flags appears to be on the way to Lee Center. Note the rig has matching horses and leather seats. The man driving might be a local hired to drive ladies to Lee Center to run their errands.

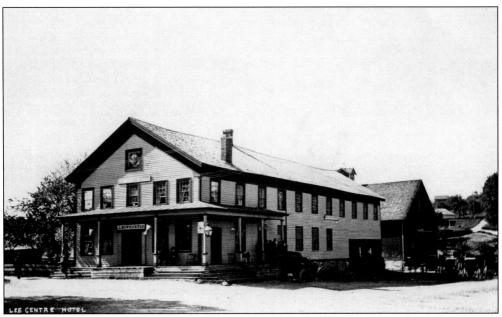

The old Lee Center Hotel was built in the early days and was later owned and operated by the Bowman brothers. Renamed the Bowman Hotel, it was a popular place for activities to be held upstairs in the big hall. The local stage, driven by Jacob Ritter, stopped at the hotel to drop off passengers. In 1918, the Bowman Hotel burned and was never rebuilt. (Courtesy of Tom Gates.)

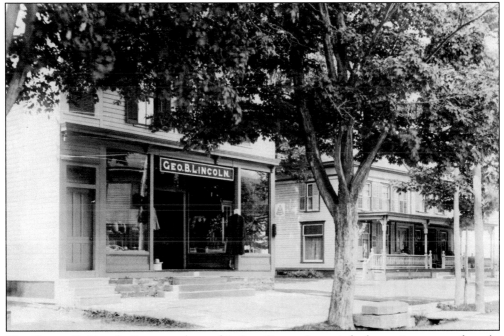

The George B. Lincoln Store was located in Lee Center. It carried a better inventory of goods, along with fine china, copper pots, fabric, lace, and leather goods. The store was a favorite meeting place for the ladies to look over the latest patterns and fashion books from Boston.

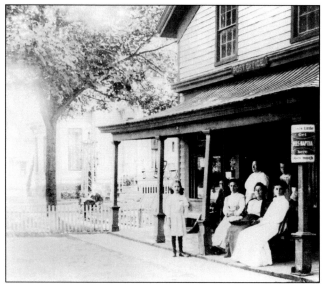

The Jay Hitchcock General Store was on Main Street in Lee Center; it was another popular store, where the men gathered to talk over the affairs of the day. Sitting are Hubert Johnson, Emma Ingalls, and Harriet Hitchcock; standing are Nellie Hitchcock and Laura Blanchard. Others in the image are unidentified. (Courtesy of Rome Historical Society.)

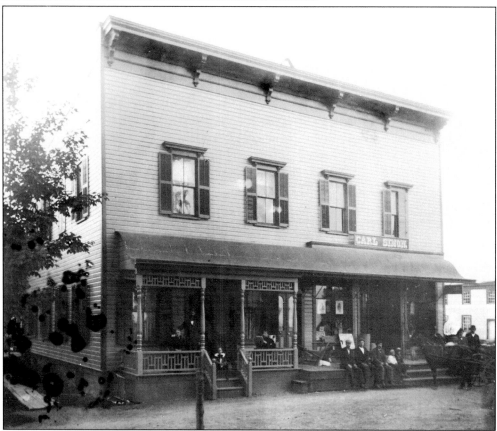

The sign on this store reads, "Carl Simon." It was another general store and gathering place for the men of Lee Center. The store carried the general items of that era, usually sold by the pound. Next to the store were the living quarters of the owners. The building still stands on Main Street in Lee Center, housing four apartments. (Courtesy of Rome Historical Society.)

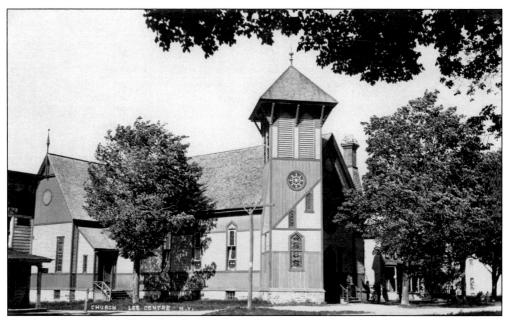

The Lee Center Methodist Church featured different types of wood with various colors. It was a true landmark in the village. In 1935, the structure caught fire and burned to the ground. The people of the village built a new brick church to replace the old one. As fundraisers, the church holds harvest dinners and rummage sales. (Courtesy of Tom Gates.)

St. Mary's Roman Catholic Church of Rome, New York, sponsored a mission church in Lee Center. After a period of time, St. Joseph's Church, a lovely native-stone church, was built on the Stokes Lee Center Road. The nearby parish center is used for religious education and other activities for the younger members of the congregation.

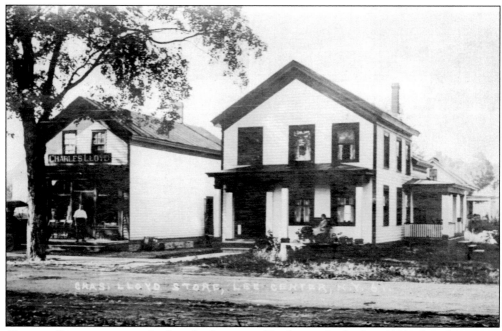

Clarence Dingman operated a bicycle shop out of his home. In the late 1890s, bicycling was a very popular pastime, with many bike paths connecting the area villages. In 1931, when the shop closed, the town turned it into the local firehouse. (Courtesy of Tom Gates.)

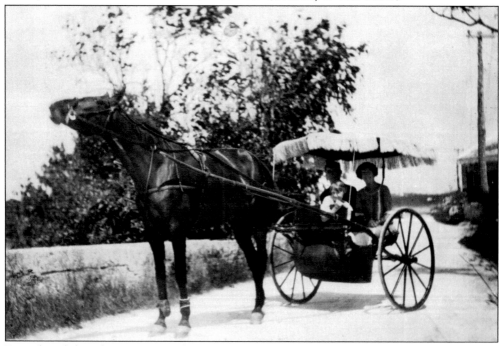

Even though bicycling was a popular pastime of the era, some individuals still enjoyed driving their own rig, drawn by their favorite horse. Rosie DeForrest was often seen around town in her rig with the fancy top. She drove from her home near Delta to Lee Center weekly to shop at the Lincoln store.

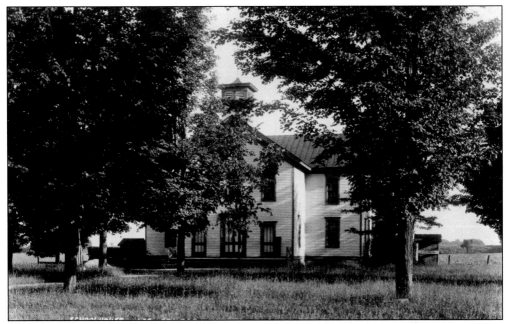

The stone schoolhouse was built in 1833 and served the children in the surrounding area. Over the years, other one-room schoolhouses were built; by 1845, there were 17 schools in the town of Lee. This school, a large two-story building, had three entry doors. When the districts consolidated with Rome, the local schools closed. (Courtesy of Tom Gates.)

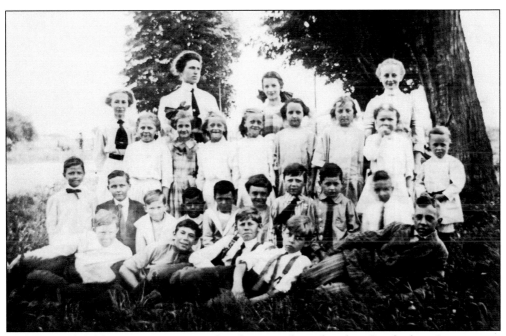

This group of children is on its way to a church picnic, dressed in their Sunday best. It is amazing that the boys were wearing ties, and one boy was dressed in a suit. Familiar names among the children are Portner, Noble, Beck, and Smith. (Courtesy of Ernest Leigh and Doris Portner.)

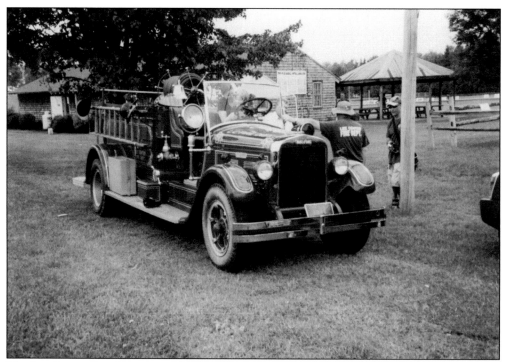

The Lee Center Fire Company was officially organized in 1931. One of the first trucks purchased by the fire department was this 1933 Ward LaFrance Fire Truck. The truck was equipped with 500 feet of hose and fire extinguishers. It was nice to have updated equipment to be able to respond to local emergencies. (Courtesy of Ernest Leigh and Doris Portner.)

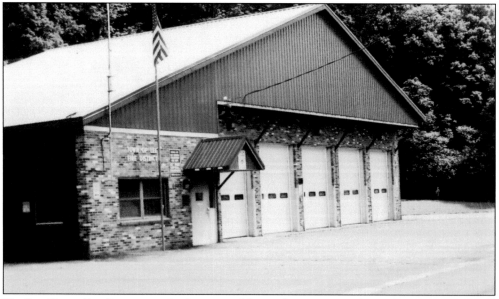

The Lee Center Fire Department built a state-of-the-art fire station on the Stokes Lee Center Road in the late 1970s. A board of fire commissioners governs the department. The Ward LaFrance truck was recently restored and displayed in the department's annual parade. This volunteer department holds field days and other fundraisers to help support itself.

When the Olney and Floyd Canning factory was forced to leave the village of Delta in 1910, it moved to Lee Center and was ready for its first pack in the summer of 1912. The bricks from the cannery in Delta were used to construct the huge chimney at Lee Center. The man standing at the top of the scaffolding is Frank Warcup, a master builder.

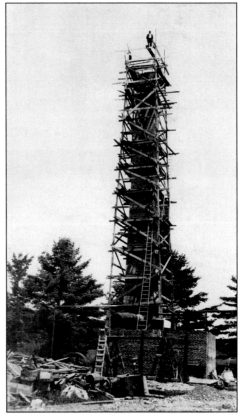

For 60 years or more, the cannery continued to produce canned beans, corn, pearl onions, succotash, peas, and pumpkin. The produce was canned under many different labels, but the most notable was the Butterfly Brand. After closing, the buildings were sold and fell into disrepair.

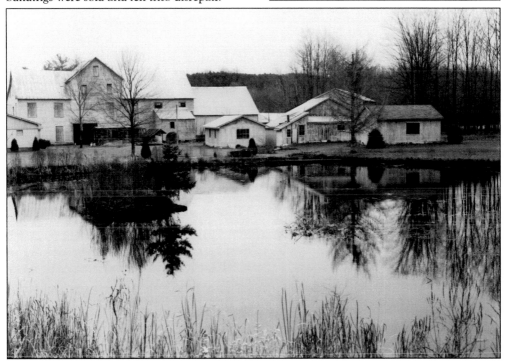

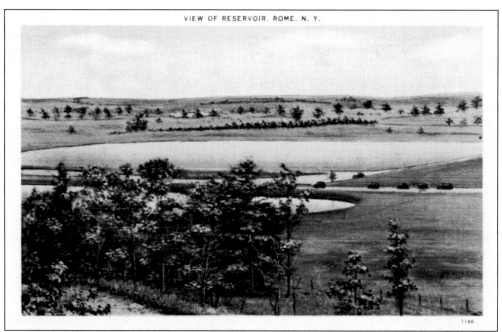

1166

A better source of water was needed for the city of Rome, and so, plans were made to build a dam on the Fish Creek in Annsville. Construction began on the Kissinger Dam in 1908, along with a gatehouse. Farmland was purchased on the Stokes Lee Center Road to build a holding reservoir. From the Stokes reservoir, water is piped to the city of Rome.

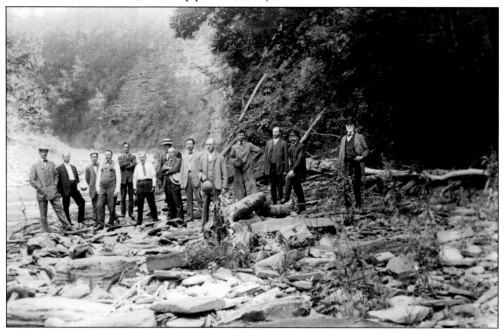

A 5,500-foot tunnel was constructed from Kissinger Dam to the reservoirs at Stokes. After leaving the tunnel, the water enters a six-mile concrete aqueduct that crosses the entire width of the town of Lee. The water is treated at the modern filtration plant that was built at the reservoir site. (Courtesy of Ernest Leigh and Doris Portner.)

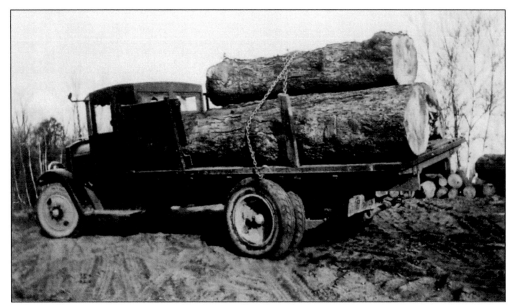

A load of logs is on the way to a local sawmill. These logs are a fine example of the size of trees on surrounding hills cut from virgin forests. These maple logs were used for beams, flooring, furniture, and cabinets. Many individuals made their living by logging the local forests. (Courtesy of Ernest Leigh and Doris Portner.)

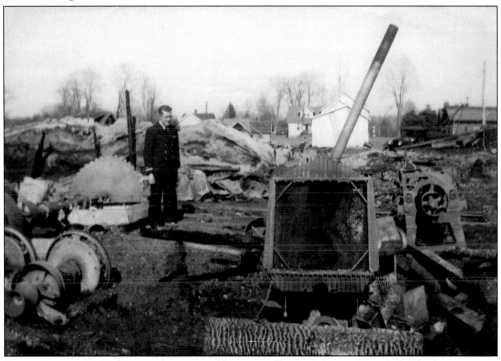

Ernest Portner Sr. looks over the ruins of his sawmill, which burned in 1945. The business was a total loss, with the machinery becoming piles of rusting metal. Shortly after the fire, work to rebuild began, and it did not take long before the mill was up and running. (Courtesy of Ernest Leigh and Doris Portner.)

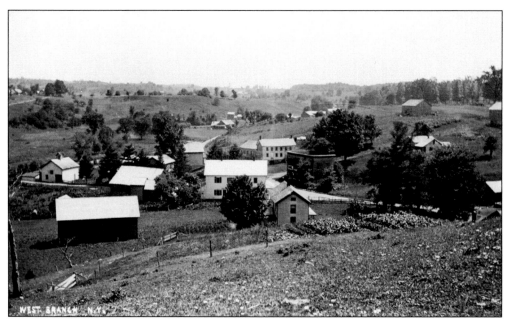

Here is a bird's-eye view of West Branch, a small hamlet on the old turnpike road to Turin. Farming was the main occupation along with sawmills located on the nearby Mohawk River. It was a good community, nestled in the hills, where everyone knew each other. (Courtesy of Tom Gates.)

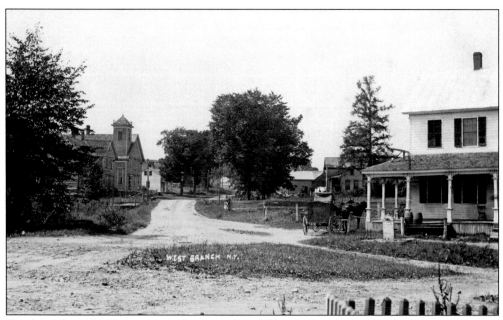

On the right is the Houser general store in West Branch. Local residents and farmers went to this store for needed supplies. Household goods and parts for farm implements and hardware were available. The stage served the hamlet, bringing visitors, mail, and supplies. (Courtesy of Tom Gates.)

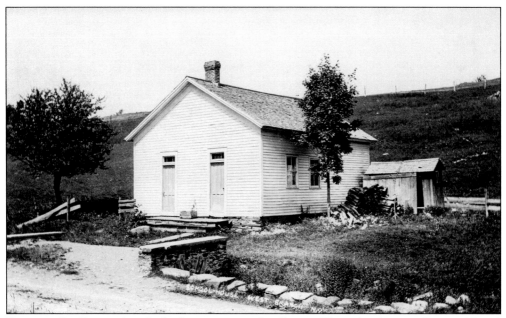

Every small village or hamlet had a one-room schoolhouse. This school was in District No. 13 in the town of Lee. It was next to the West Branch store and Houser Road. Two of the teachers were Huntley Harger and Belle Harger. Joseph Wallace was the trustee and was in charge of this school. (Courtesy of Tom Gates.)

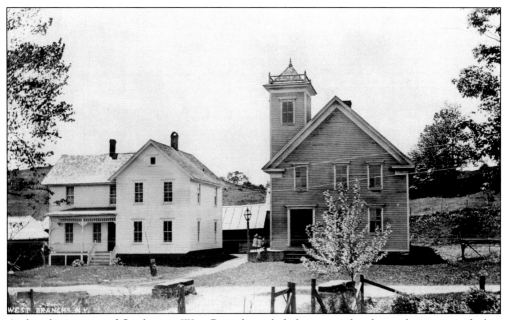

A close-knit group of Quakers in West Branch settled close to each other to be more unified in their beliefs. They established a church and parsonage in the middle of the hamlet, facing the plank road. A Quaker burial ground is located not far from the church, with fieldstones marking the graves. (Courtesy of Tom Gates.)

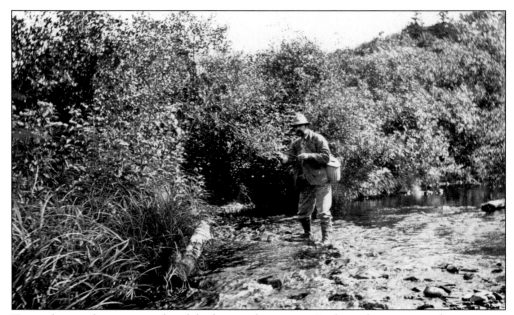

To supplement dinner, men often fished in nearby streams. In the early morning or late evening, they could be seen fishing. Trout was a favorite catch, along with bass, perch, and sunfish. On those warm summer days, the nearby Canada Creek and west branch of the Mohawk River were local swimming holes.

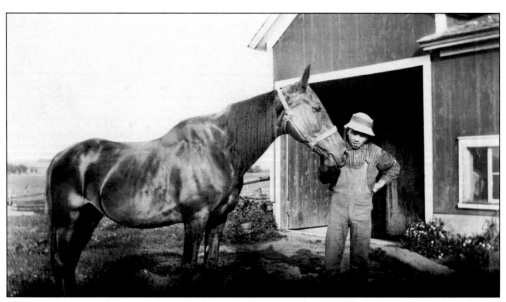

Horses were very valuable in the early days; not only were they used for transportation but also for farming. Owners loved to show off their prized horses. Even this young farmer near West Branch was proud to show his family's valued possession.

This is the famous rock formation from where the hamlet of Point Rock got its name. The large outcropping of shale rock is where Fish Creek and Point Rock Creek converge. Point Rock supported a large lumbering industry with abundant trees on the nearby hills. In 1870, a Methodist church was built, which still serves its congregation today.

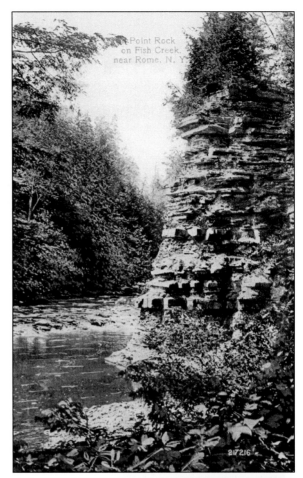

E.W. Blessing general store provided local farmers and lumbermen with needed supplies in the Point Rock area. The stage from Rome came to the village once a day. Individuals could ride the stage back to Lee Center or Rome. (Courtesy of Tom Gates.)

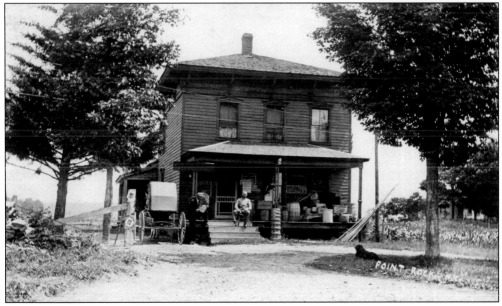

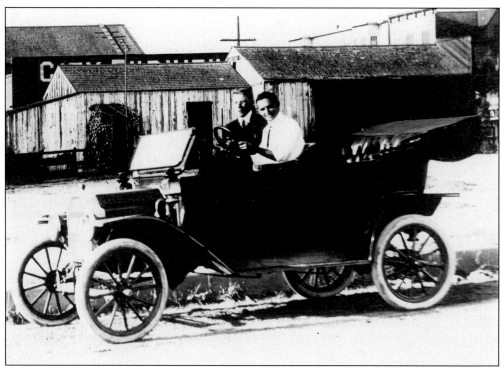

Stokes was a small hamlet between Delta and Lee Center; it was originally called Nesbit Corners but was renamed when Charles Stokes established a post office there. A.P. Macomber is seen stopping at the four corners to do business. Numerous homes are located on the steep hill.

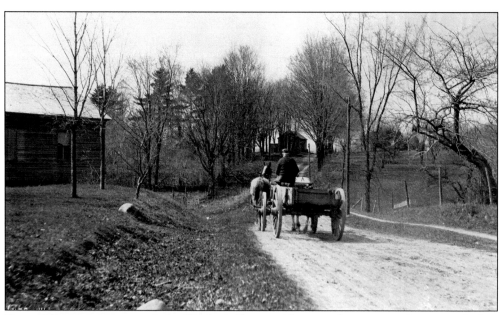

Elmer Hill is a location named after Hezikiah Elmer and his sons; they came to the area in the late 1790s and built their homes on the hill overlooking the future site of Delta. They opened many early businesses and built a large inn, which was a popular place that hosted many celebrations.

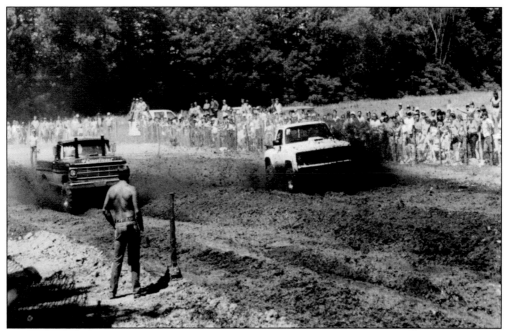

Several of the local fire departments sponsored mud drags in the late 1980s. The object of the race was to out distance the other trucks while driving on a slippery mud track. The local guys built special trucks to race in the mud only. One favorite group that participated was "Fun in the Mud Racing." (Courtesy of Eric Centro Sr.)

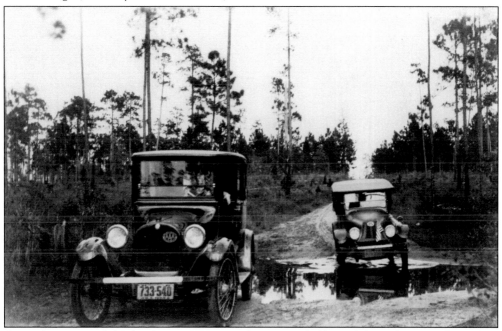

Even when automobiles first became commonplace, men challenged the endurance of their cars and trucks. Shown are two 1920s vehicles on a long-distance road race. The designated route took them through large mud holes, into the woods, and over hills and farmland to the finish line. There were no tow trucks in those days, so breakdowns and repairs had to be dealt with en route.

Located on the Elmer Hill Road, the Jacob Karlen farm was across from Delta Lake and not far from Hawkins Corners. It was a large farm with its main barn constructed of cement blocks. Jacob Karlen was a noted cheese maker in the county, winning many prizes with his cheese.

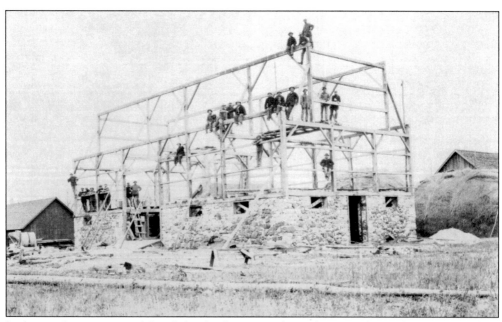

In the past few years, several Amish families have moved into the town of Lee. This is an example of a typical barn raising by an Amish community. Working together, the group raised a completed barn frame in one day. The men worked on the barn while the women prepared and served the food.

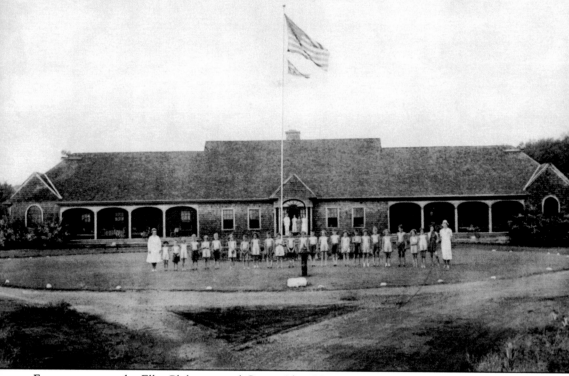

For many years, the Elks Club operated Camp Alice Newton, situated in the town of Lee, for under-privileged children. Later on, the Salvation Army owned and operated it as a summer day camp. In the early 1900s, the camp was built as a sanatorium for people with health issues. In its time, the complex being way out in the country, with its nice summer days and cool evenings, was great for those recovering from a serious illness. The camp closed in 2008 and silently sits on Turin Road.

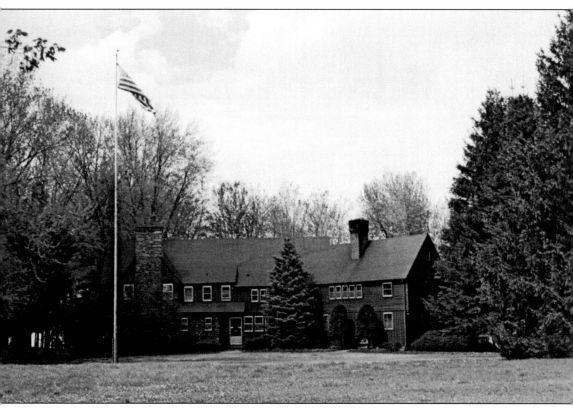

The headquarters of the Iroquois Council Boy Scouts of America was located on Golf Course Road on the shores of Delta Lake. The council provided services for Scouts and leaders in Oneida County and surrounding counties. The council held many meetings and seminars at this lovely location. In the summer, the Scouts were allowed to camp on the spacious grounds. Using the lakeshore, many young boys were taught safe boating. After the headquarters closed, the building was demolished, and two private homes were built on the site.

Three

BUILDING DELTA DAM

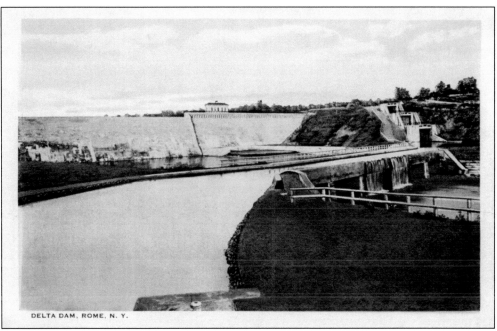

DELTA DAM, ROME, N. Y.

Delta Dam impounds the water of the Mohawk River to form a reservoir that supplies water to the New York State Barge Canal System that recently was renamed the new Erie Canal. The dam structure stretches 1,700 feet across the valley opening. The dam spillway rises 100 feet above the Mohawk River below. Next to the dam are three combined locks that carry the Black River canal boats up or down the steep nearby palisade cliffs. At the foot of the dam, the canal is carried across the Mohawk River via an aqueduct and continues on to Rome or up to Boonville. The dam was completed in the fall of 1912.

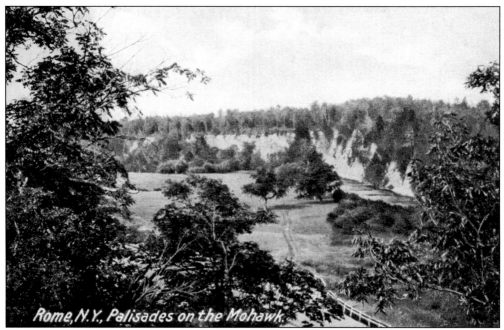

The beauty of the palisades is not surpassed anywhere else in the county. The cliffs on the east side of the valley are more than 200 feet high and the cliffs on the west side are 85 feet high, forming a narrow opening to the valley. The state engineers felt this was the perfect place to build a dam, impounding the waters of the Mohawk River to create a holding reservoir.

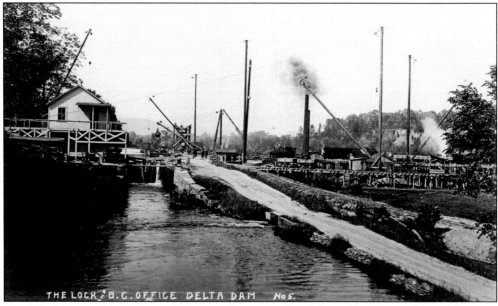

The Black River Canal channel kept to the west side of the valley. Located near the west palisade was a lock where the boats were raised or lower into the canal. This lock was rebuilt about 100 yards south when the dam was constructed. The relocated lock and towpath are still in existence today.

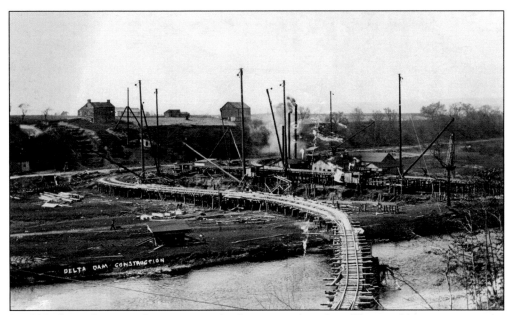

In 1908, this is the start of construction for the impounding dam. The step-like structure on the west palisade is the beginning of excavation for the west retaining wall of the dam. The dam is literally built between the railway tracks and the scaffolding. Seen on the hill is the old Native Indian trading post, which had been there for more than 200 years.

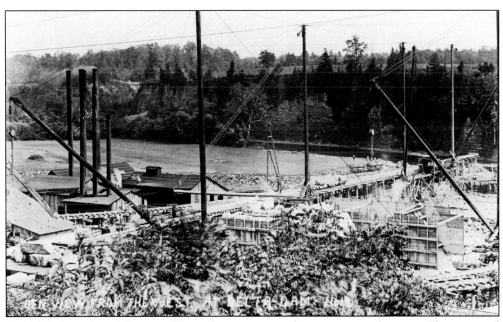

New York State Canal Contract 55 was the greatest canal contract up to that time. The estimated cost of the project was to be more than $1 million. Twelve bids were received with the contract being awarded to Arthur McMullin of New York City. Equipment came on-site in the fall of 1908 to begin construction.

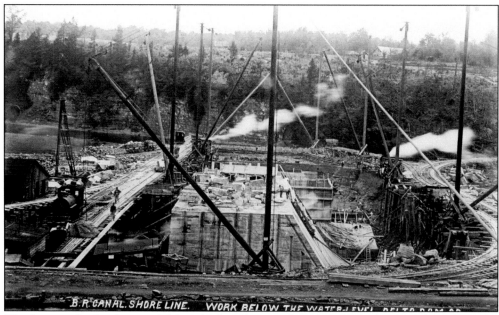

B.R. CANAL. SHORE LINE. WORK BELOW THE WATER LEVEL DELTA DAM 20

The footings for the dam are 85 feet thick and are anchored in the bedrock of the valley. The bedrock had been tested, and the engineers felt that, once the footings were in place, they would not move and there would not be any water seepage under them.

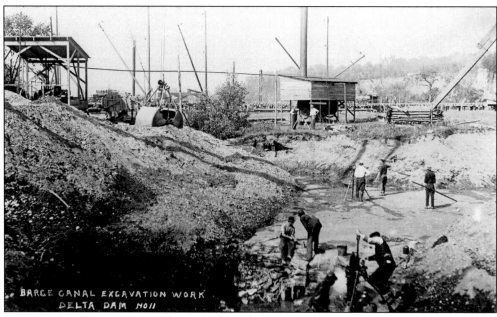

BARGE CANAL EXCAVATION WORK DELTA DAM No11

Steam-operated water pumps were used to keep different work sites free of water. In the forefront, the men seem to be digging a drainage channel. Shown are two survey teams, still laying out the area. In the distance can be seen the palisades and switchback rail tracks.

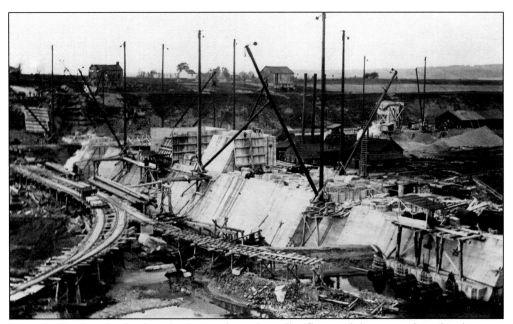

Here, the footings for the dam slowly rise above the valley floor with booms and overhead cranes. In the bottom right-hand corner can be seen the four discharge pipes that allowed the reservoir waters to be dispersed into the pool below the dam and eventually into the Mohawk River.

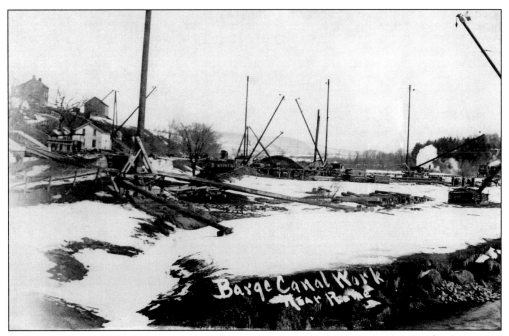

Even in the wintertime, work continued at the construction site. Contract 55 called for the tearing down of the village of Delta; relocating the Black River Canal; and building the combined locks cement aqueduct, and impounding dam.

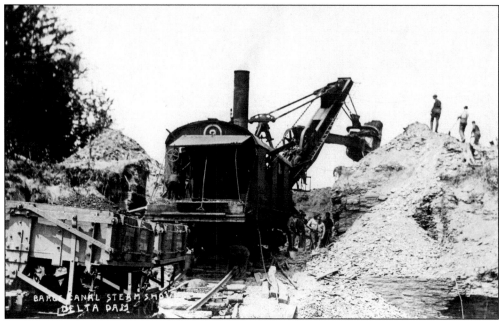

The 70-ton self-contained steam shovel was an important piece of equipment that helped build the impounding dam. The shovel was moved to the construction site from Rome under its own power over a set of temporary rail tracks. As the shovel moved forward, the tracks behind were picked up and placed in front. It took three weeks to move the shovel from Rome to the dam construction site.

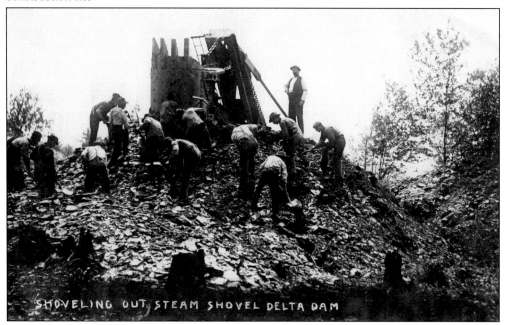

Sometimes the shifting shale and dirt caused the mighty steam shovel to become stuck. This picture shows the shovel hung up in a pile of sifting shale. Numerous workers are trying to free the massive machine, with the foreman in the hat overseeing the work. Shale is a form of soft rock similar to slate.

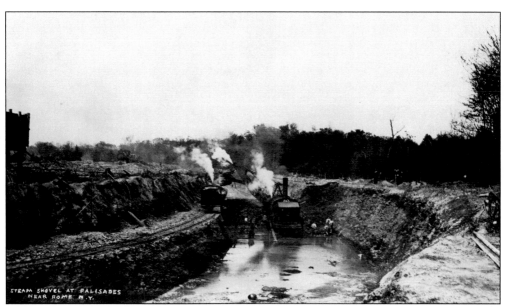

One of the steam shovels used at the construction site can be seen digging the new channel for the Black River Canal. On a temporary basis, the rail tracks for the switchback railroad are laid in the new canal bed. This small railroad hauled sand from the Frenchville sandpits to the construction site.

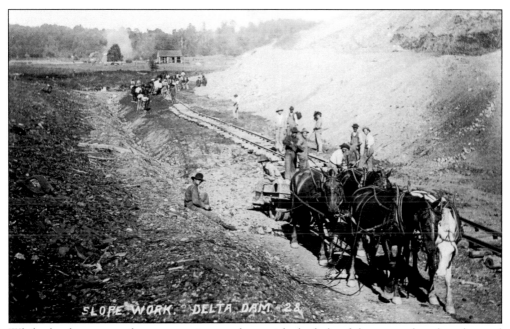

While the dam was under construction, workers, with the help of the steam shovel, mules, and horses, dug the new canal bed that would carry the canal along the top of the palisades. The mules and horses were housed in Delta during the winter.

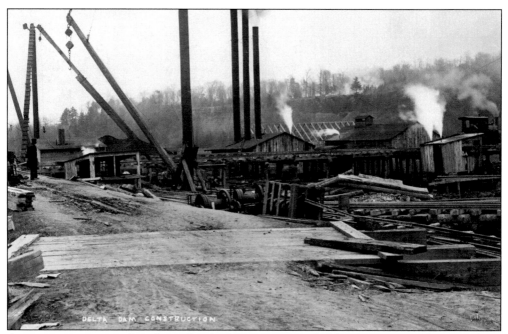

As construction started in the valley, buildings were needed for the various jobs around the site. As soon as the contract was awarded, construction started on the outbuildings, a machine shop, a boiler room for the steam boilers, sheds for the small work engines, a repair shop, and a temporary lock house.

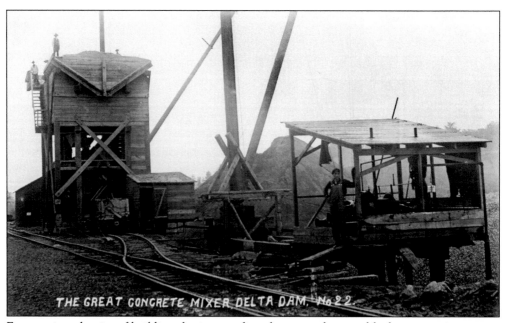

For a project the size of building the impounding dam, aqueduct, and locks, an on-site cement mixer was necessary. The mixer was a cubical steel box and auger powered by a steam engine; it mixed two cubic yards at a time. The mixer was located near the canal where the sand and crushed stone were stored.

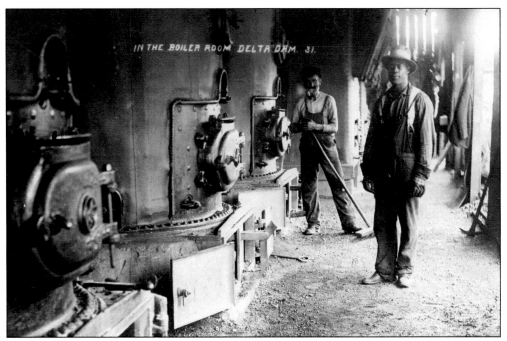

The boiler room was one of the most important buildings at the construction site. The three coal-fired boilers supplied the steam power needed. Standing in the foreground is Monroe Harris, one of the workers who did many of the needed tasks at the site.

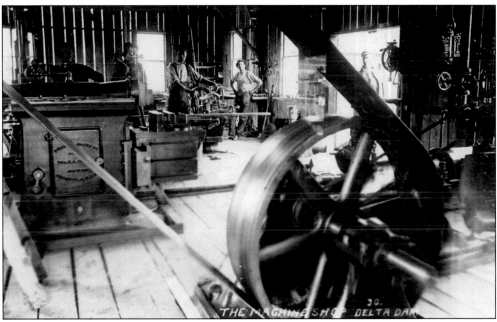

Another important building was the machine shop where needed parts could be made or repaired. In the background can be seen the many machines lathes, drill presses, and metal vices. It is unclear what the large belt-driven wheel was used for.

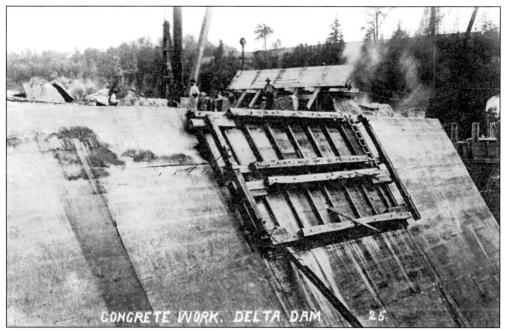

CONCRETE WORK. DELTA DAM 26.

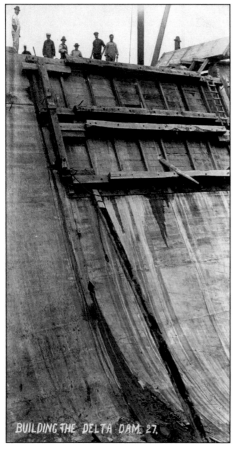

BUILDING THE DELTA DAM. 27.

Wooden forms the size of a barn wall held the 85,000 cubic yards of concrete that were used to construct the dam. Huge rocks that came from the Sugar River quarries above Boonville make up 50 percent of the mass of the dam. The rocks came to the construction site via the Black River Canal.

As the men work on a section near the top of the dam, the large concrete forms can be seen. It must have been hard work placing these massive wooden forms in place, even with the help of a crane. According to the state, there is no truth to the folklore that men fell into the open forms and were buried in the concrete of the dam.

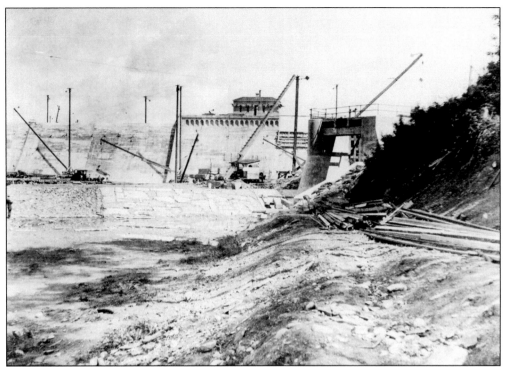

As the hillside was excavated, the three locks begin to rise. Steam-operated pumps helped keep the water away from where the men worked. Heavy rains created large pools of water, and sometimes the pumps were overloaded.

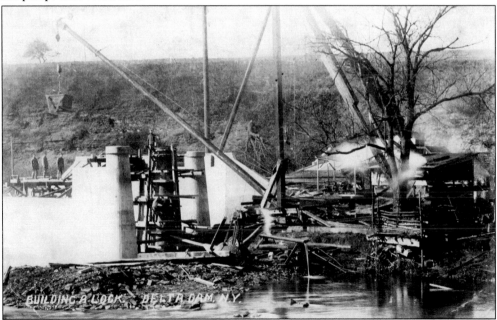

The lower lock of the three is seen under construction with its round sides and sturdy walls. Being built near the channel of the Mohawk River, the ground had to be swampy, and in order to hold the huge structure, the area had to be dug down to the bedrock.

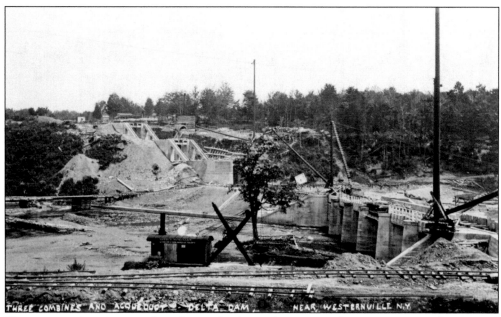

The construction site must have been a beehive of activity with men coming and going and equipment moving about the site. Seen are the three locks almost complete and work being done on the cement aqueduct. The big steam shovel can be seen in the foreground, along with the railway tracks.

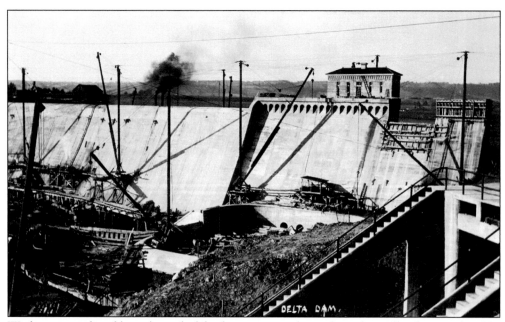

Work progressed swiftly as the end of the four-year time frame drew close, all to be completed by fall 1912. The impounding dam appears to be almost complete, with some equipment still on-site. The holding pool and the discharge pipes at the foot of the dam are in place. The gatehouse sits complete at the top of the structure.

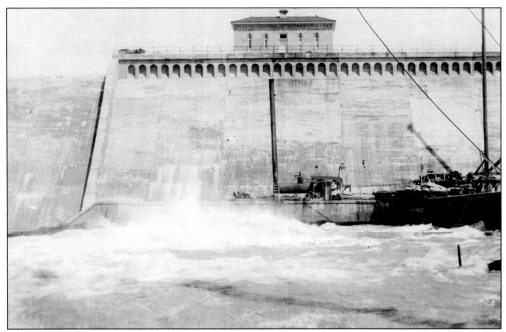

The four sluice gates on the backside of the dam regulate the amount of water released from the reservoir. In the spring, when the lake is high, large amounts of water flow through the pipes into the holding pool at the foot of the dam. As the water leaves the pipes, it can jump 40 to 50 feet in the air.

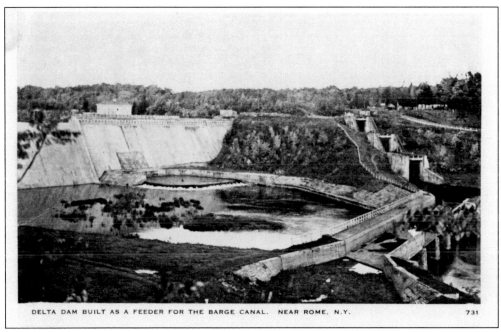

DELTA DAM BUILT AS A FEEDER FOR THE BARGE CANAL. NEAR ROME, N.Y. 731

This is a nice view of the completed impounding dam, locks, and cement aqueduct. Note that the area has been cleaned up. The construction equipment is gone; the hillside looks pristine without trees. There seems to be debris in the cement aqueduct, but no water yet. The job is almost done.

Frank Hurlbut owned the land where the impounding dam was built. Building an addition to his home, he created a rooming house for the workers. Many of the workers stayed at the Delta Dam Hotel while others lived in the empty houses in the village.

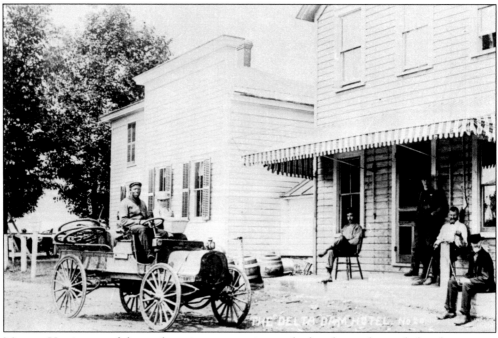

Monroe Harris, one of the workers, is seen stopping at the hotel to pick up a lady, who appears to be taking a food basket to the construction site. Driving an early-era automobile with wooden spoke wheels, Harris probably ran many errands to and from Rome.

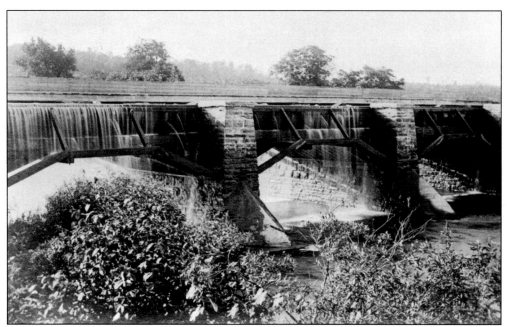

The Mohawk Aqueduct carried the Black River Canal over the Mohawk River, a short distance from the Palisades. The wooden aqueduct was built on stone piers with a wooden structure above. Four feet of water flowed over the wooden floor and carried the canal boats on their way.

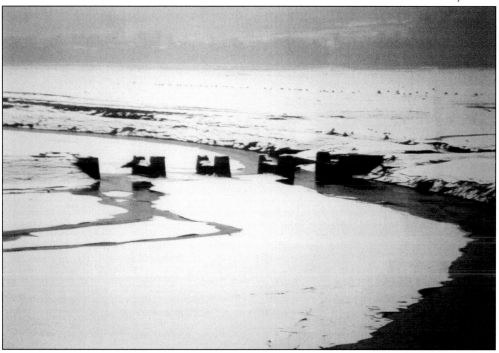

This is all that remains of the large Mohawk Aqueduct that carried the canal boats over the Mohawk River. This photograph, taken in the winter of 1958, shows the stone piers and the river still flowing between them. At the state park, looking toward the dam, the old remnants are off to the right. (Courtesy of the Engelbert family.)

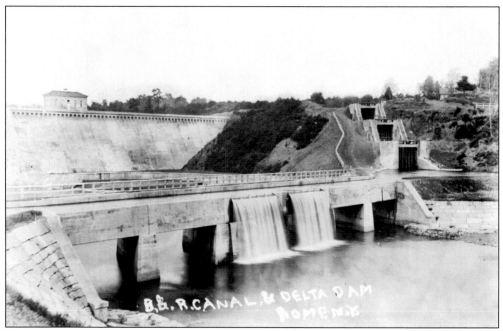

The building of the impounding dam is done. Shown are the gatehouse, the fence along the towpath locks with doors, water going over the aqueduct, and the limestone blocks that reinforce the surrounding slopes. This site soon became busy with traffic on the canal and tourists.

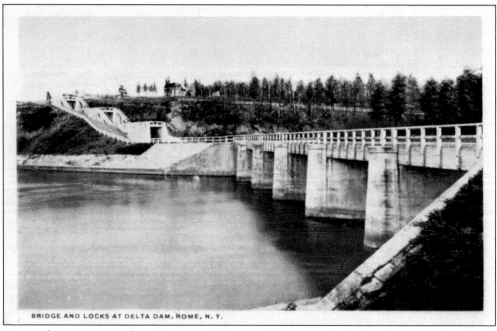

BRIDGE AND LOCKS AT DELTA DAM, ROME, N. Y.

Here is the cement aqueduct that carried the canal boats over the Mohawk River at the foot of the dam. The structure was used from 1912 until 1925, when the canal was closed. Over the years, it has stood as tribute to its builders. The aqueduct is now fenced off for safety reasons.

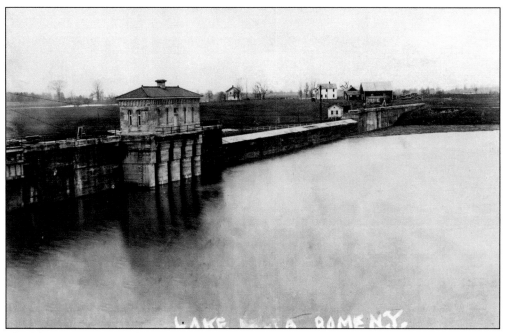

The lake slowly began to fill up, with the level controlled by the state. Seen here is the backside of the dam, with the gatehouse and four sluice gate openings. In the distance can be seen the Delta Dam Hotel, old lock house, the west retaining wall, and remnants of the palisades cliffs.

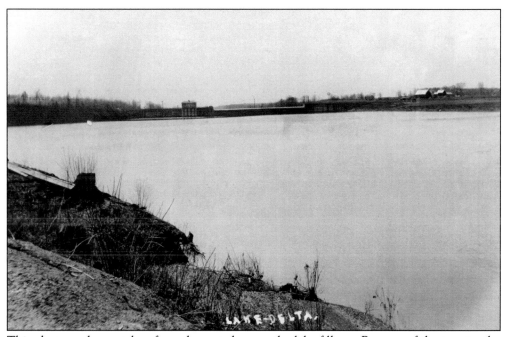

This photograph was taken from the east shore as the lake fills up. Because of the terrain, the banks in this area are steep along the state highway. Over the years, large limestone blocks have been placed on the shoreline to stop erosion. People wanting to fish manage to climb down the rocks.

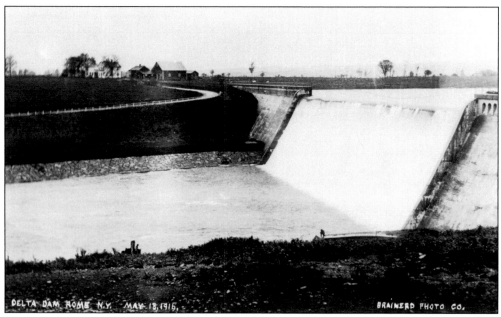

Water first went over Delta Dam on May 16, 1916, taking over four years for surplus water to flow. In order to give the concrete in the dam time to cure, the State of New York controlled the flow. This photograph was taken on May 18, 1916, just two days after water first went over the dam.

The completed complex quickly became a tourist attraction with people coming from as far away as Albany and Syracuse. Many traveled with horse and buggy while others came in automobiles. Behind this shiny automobile, one can see the dam, gatehouse, and the three combined locks. (Courtesy of the Dixon family.)

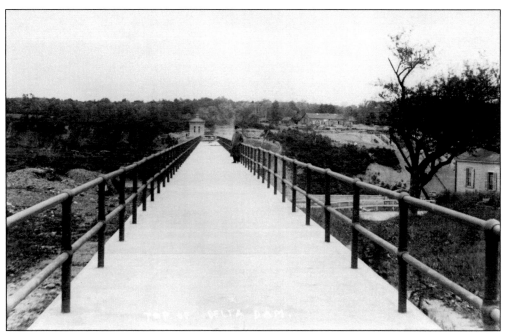

In the early days, tourists could walk out on the west retaining wall to look at the top of the dam and watch the water. There does not seem to be any gate or fence at the far end of the walkway. Today, this area is fenced off, and the public is not allowed access.

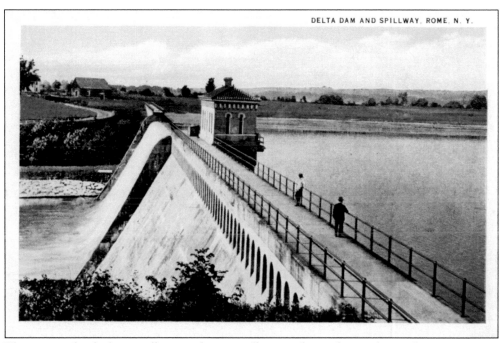

These two individuals are walking on the east walkway to the gatehouse. Again, there is no gate or fence at the end of this walkway. For safety concerns, this walkway is also closed to the public.

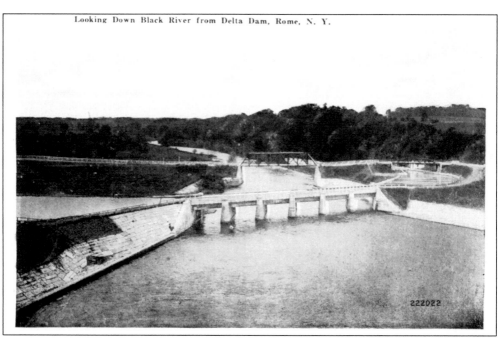

This is a nice view of the cement aqueduct at the foot of the dam. Beyond it can be seen the steel-deck bridge that carried traffic over the Mohawk River. One can see how the canal swept to the right so that the boats could enter the lock at the correct angle. Over the years, this area changed with the closing of the canal.

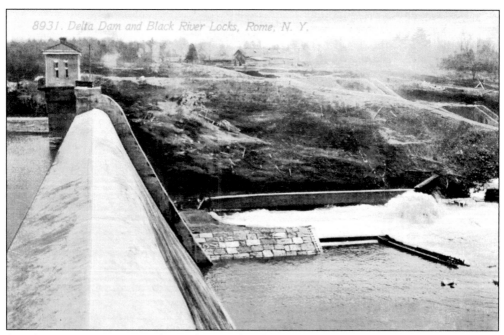

8931. Delta Dam and Black River Locks, Rome, N. Y.

Another tourist attraction is the pool or pond at the foot of the dam. It is mesmerizing to watch the water jump and twirl. It is reported that there is good fishing where the surplus water flows into the river; many large trout have been caught here.

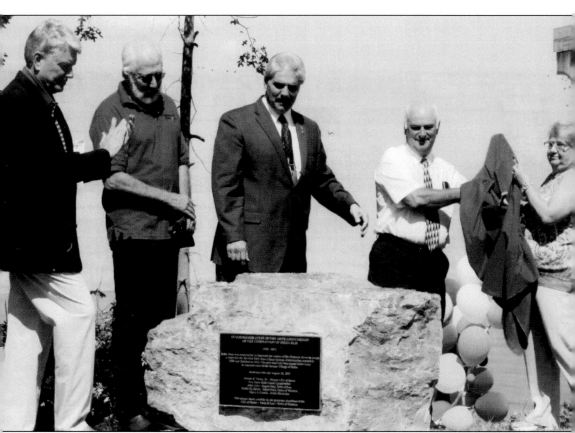

A committee was formed early in 2012 to celebrate the 100th anniversary of the completion of Delta Dam. Edward Davis of Lee Center and Mary Centro of Westernville chaired the committee. The group met every week for four months to plan the celebration on August 26, 2012. The celebration included historical and environmental displays, horse-drawn wagon rides, food, children activities, and speeches. More than 500 people attended to celebrate the anniversary and the dedication of a plaque to commemorate the occasion. Unveiling the monument and plaque are Brian U. Stratton, commissioner of New York Canal Corporation; Thomas Stevens, representing Robin Davis of the town of Western; Joseph R. Fusco Jr., mayor of the City of Rome; John Urtz of the town of Lee; and Mary Centro, Delta historian.

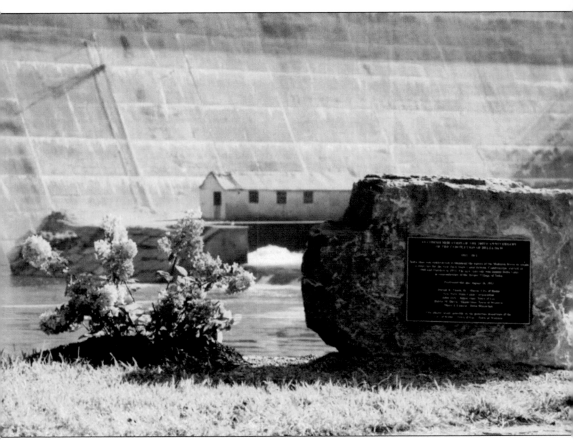

The 100th anniversary committee needed an appropriate stone on which to place the plaque to commemorate the completion of the dam. The town of Western Highway Department donated a grey limestone rock that matched the rocks near the dam. The stone was placed on a landscaped site, prepared by the Western Highway Department. Part of the plaque reads, "Delta Dam was constructed to impound the waters of the Mohawk River to create a reservoir for the New York State Barge Canal System. Construction started in 1908 and finished in 1912. The new reservoir was named Delta Lake in remembrance of the former village of Delta." The plaque was made possible by the generous donations of the City of Rome and the Towns of Lee and Western.

Four

DELTA LAKE

Delta Lake covers more than 4.8 square miles and 3,000 acres of land. In all, the lake can contain 2.7 billion cubic feet of water. It has become a favorite place for boating, swimming, and water sports. Some good-sized great northern pike have been taken from its waters, along with bullheads, bass, pickerel, and perch. Rowing regattas have been held on its cold waters each May, and in August, there were powerboat races. In the winter, the lake has hosted championship snow mobile races. Ice fishing has become a popular sport on its frozen surface. One of the best and most popular state parks is located on its southern shore, offering camping, swimming, fishing, and hiking. The lake is a beautiful place with its sparkling water and peaceful atmosphere.

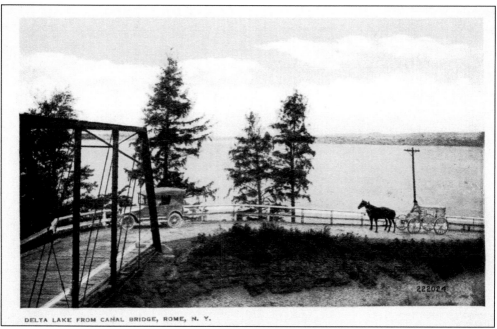

DELTA LAKE FROM CANAL BRIDGE, ROME, N. Y.

The road was reconfigured and went up the steep Delta Dam hill and continued along the new channel of the Black River Canal. Many people came to see this man-made lake, which was considered a modern marvel of its time. In the distance is Teugega point, the future site of many lovely homes.

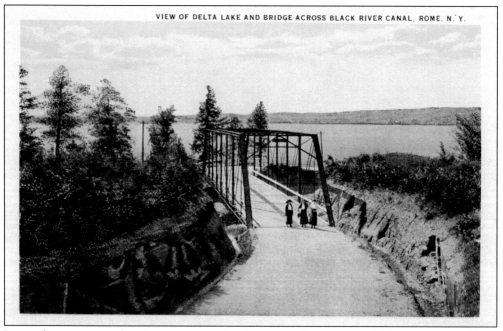

VIEW OF DELTA LAKE AND BRIDGE ACROSS BLACK RIVER CANAL, ROME, N. Y.

Located near present-day Town Line Road, a bridge carried the state highway over the Black River Canal. Locals called it the black bridge and were wary about crossing it because it came from the former village of Delta. In the late 1920s, the bridge was taken down, and the area was filled in.

As the lake filled up, many of the roads leading into the village became dead ends, such as Short Hill Road. In the early 1840s, this road became the main route north through the village. Out in the lake can be seen telegraph poles that were left to measure the depth of the water. (Courtesy of Rome Historical Society.)

As the lake filled with water, many of the small openings among the hills became secluded coves. Through a ravine, an old dirt road curved off the current Stokes Westernville Road and helped create this cove where a boathouse once existed. A couple is seen having a picnic here near the lake.

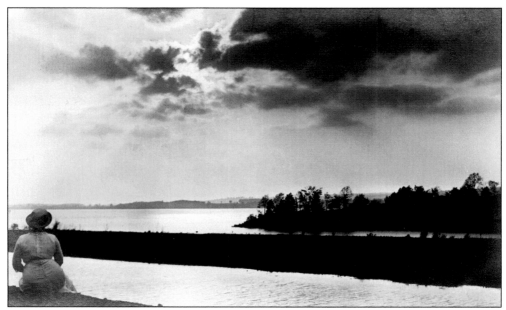

The scenery around Delta Lake is beautiful and never ceases to amaze. A local lady sits on the shoreline to watch the sunset. Some evenings, the setting sun paints the sky with golden colors of oranges, reds, and delicate pinks. The inlet, near the point of land, will become the boat launching channel for the state park.

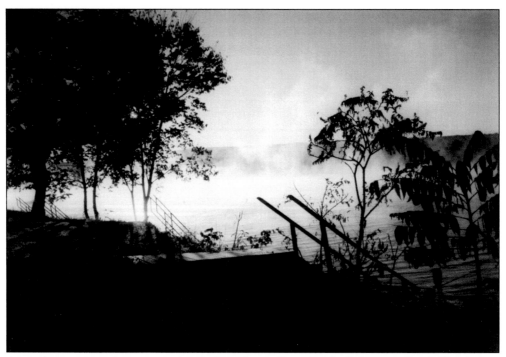

An early morning mist starts to rise up from the surface of Delta Lake near the A-Ok Marina. Cool morning air touching the warm water creates the mist and sets this scene as the sun rises. The marina is one of two privately owned boat-launching spots on the lake.

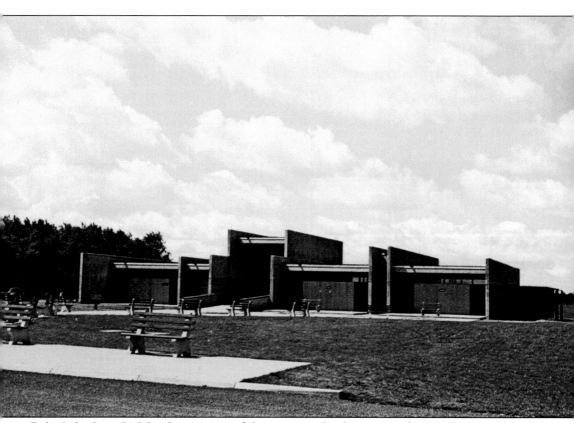

Delta Lake State Park has become one of the most popular destinations for people near and far. After several years and much study, the state decided to build a park on the shores of the lake. Actual work on the park began in the spring of 1965 and was open for business in July 1966. The concrete bathhouse serves the bathers who come to swim, under the watchful eye of lifeguards, on hot summer days. Some shoreline campsites have direct access to the lake. Each campsite has a picnic table, grill, or fire pit with water outlets and shower facilities nearby. Over the last few years, the bathhouse and other areas have undergone renovations, creating a better facility for visitors.

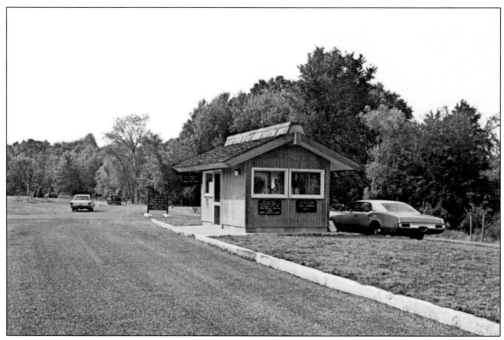

This is the gate at the entrance to the Delta Lake State Park. Campers and beachgoers check in here and pay the required fees. Several years ago, this building was remodeled and enlarged with an indoor reception room and wider driveway to accommodate campers.

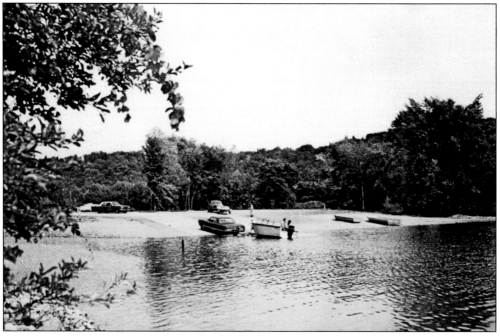

The concrete boat-launching ramp serves both fishermen and boaters. When the ramp was first installed, it was only one ramp with no docking facilities. Improvements to the ramp have been made with two concrete launching pads and finger docks on each side.

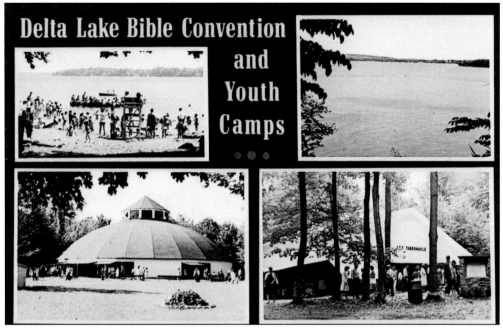

On the northwest shore of Delta Lake is located the Delta Lake Bible Convention and Youth Camp, run by the Christian and Missionary Alliance Church. The center hosts weeklong Christian seminars and weekend retreats. The grounds have camping areas for families and others. The camp offers swimming and boating, along with Christian worship services.

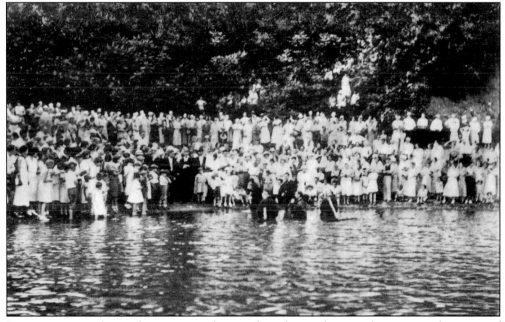

In past summers, the conference center has conducted group baptismal services in the waters of Delta Lake. Individuals travel from all over the Northeast to renew their faith at the center. An early Delta settler, Israel Stark, witnessed the baptism of his family in the Mohawk River before his death a few days later.

The tabernacle building at the Bible Conference Center was built as a place of worship. Many noted ministers gave sermons here along with group Bible study. For special occasions, the building served as the main dining hall for banquets and covered-dish dinners.

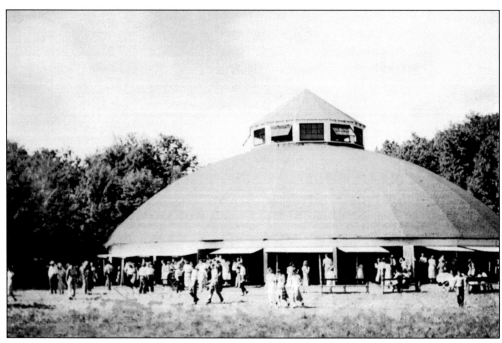

Over time, the old tabernacle building was aging and needed updating. It was decided to construct a new one. The beautiful domed tabernacle is the centerpiece of the complex. The building can seat 1,400 people and is a source of great spiritual blessing.

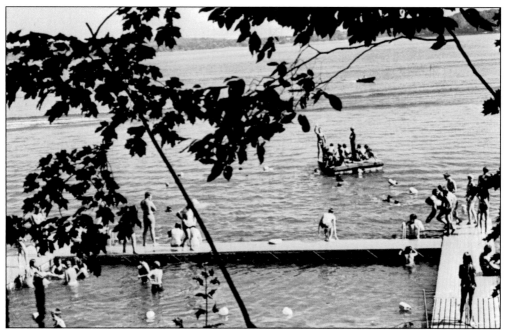

Part of the daily routine at the camp is swimming and boating on the lake. The land naturally sloped to the lake, forming a nice cove and beach. Nearby lifeguard stations keep a watchful eye on the swimmers and boaters. Many of the campers learned to swim here.

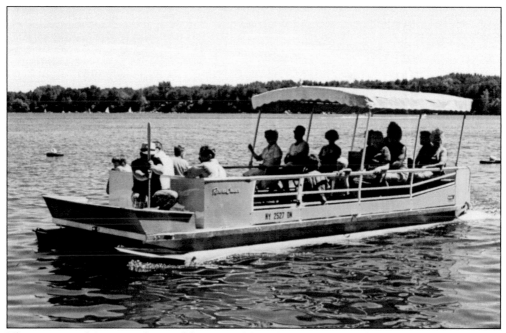

This pontoon boat was obtained by using S&H Green stamps, which were collected from congregations all across the Northeast. In the 1960s, Green stamps were premiums given at supermarkets, and they could be turned in for merchandise. The boat is used today as a floating swim dock at the camp.

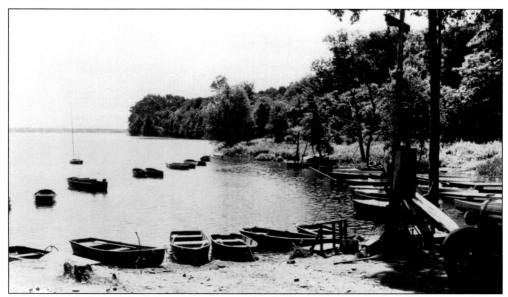

From the early days of the lake, enterprising individuals operated several small boat rental sites. One rental site that has lasted over the years is Anson's Boat Livery. The small marina was one of the popular places to rent boats for fishing. The family-owned business still exists on the north shore and still offers boat rentals. (Courtesy of Ray Anson.)

Other campsites offered canoes and simple rowboats to their friends and guests. A popular pastime then and now is being on the water, either canoeing or powerboating. Kayaking is the favorite mode of transportation on the lake in the spring and early fall.

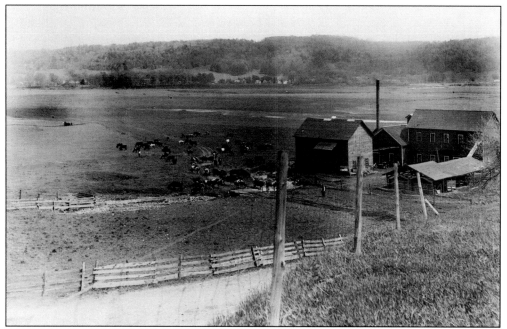

When Delta Dam required repairs in 1925, the lake was drained in order to inspect the back of the dam. At that time, farmers were able to grow crops on land that had been underwater. Closer to the village of Delta, fields of corn and wheat could be seen. Near the Mohawk Valley Canning Company, owned by W.F. Pillmore, his cattle were able to graze near the Mohawk River. Main Street in the village was dry and solid; people were able to walk down it as before. (Courtesy of Rome Historical Society.)

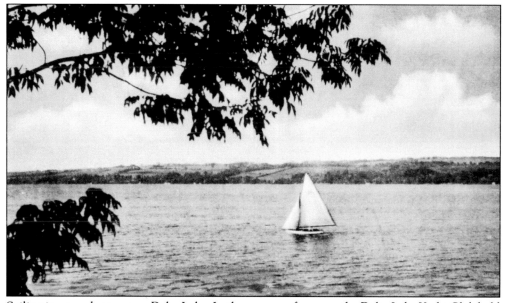

Sailing is a popular sport on Delta Lake. In the summer, for years, the Delta Lake Yacht Club held sailboat races every Sunday morning. Different class boats raced, with the most popular being the Lightning Class. Close-by residents could hear the firing of the starting gun that signaled the start of the races.

Stokes Cove became a favorite location to swim and boat. The old road from stokes allowed easy access for boat launching. The large cove and sloping lakebed made it a good place to swim. From the 1920s, many picnics and parties were held there. Good fishing was also found in this sheltered area. In the evening, the cove was a lovers lane. The cove fell out of use with the opening of the state park.

Teugega Country Club was formed in 1899 by a group of men from Rome, headed by Franklin Ethridge. The men had been playing golf in a pasture off Turin Road, but the grass was often too high and the bulls not friendly. They decided a new golf course was needed, so land was leased near the Mohawk River, present-day Mohawk Acres. On Memorial Day 1900, the club officially opened. The course was laid out on low-lying land that was wet when it rained. A new location needed to be found. Land was purchased six miles north of Rome on the shores of Delta Lake. Donald Ross, designer of many English courses, was retained to build the new course. In July 1925, a formal celebration was held to mark the opening of the new golf course.

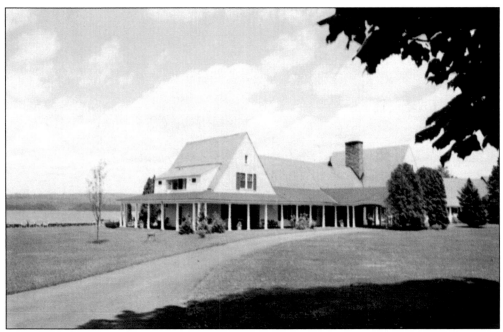

Teugega is the Native American word for the Mohawk River; it means, "Forked River." The original clubhouse has been enlarged and renovated many times. A larger dining room and bar area was added to accommodate receptions and parties. Locker room facilities were also improved.

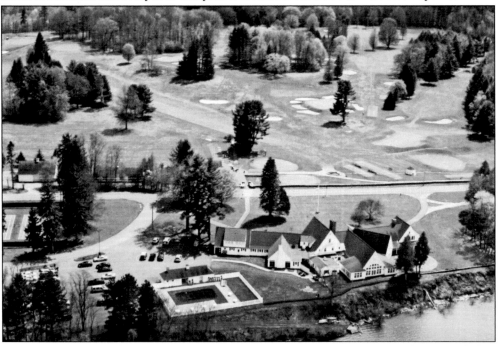

An aerial view of the Teugega Country Club complex shows the many recreation choices, including tennis and swimming, for its many members. Docking facilities were recently added on the lake. The Donald Ross–designed 18-hole golf course stands out as a shining jewel in the countryside. (Courtesy of Mike Huchko.)

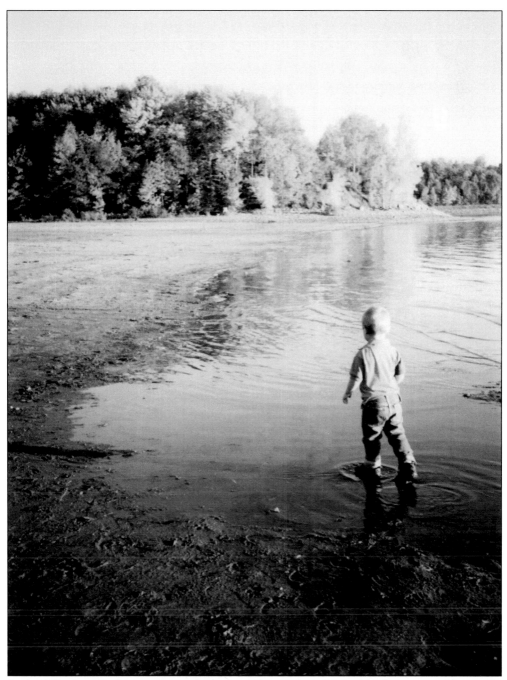

In the fall, when the leaves start to change, people travel up the state highway toward Boonville to view the colorful landscape; many of these individuals stop at the state park to see the lake. Jacob Reed, age four, is enjoying the low water while strolling the beach. When the state built the park, loads and loads of sand were trucked in to create a nice sandy beach. By placing the sand 100 yards into the water, the swimming area is one foot to six feet deep and guarded by buoys. In the summer, the beach is under the watchful eye of lifeguards; it closes at Labor Day. After that, one can still walk the beach and enjoy the outdoors. (Courtesy of Jacob Reed.)

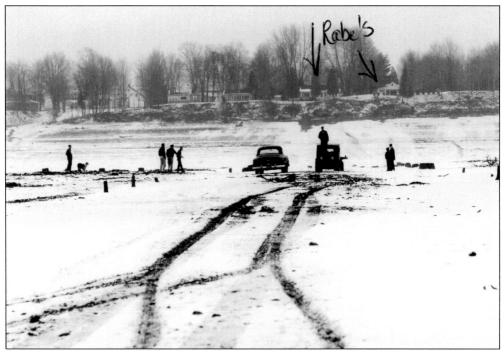

In the winter of 1957, the lake was low enough to drive vehicles on Main Street in the former village of Delta, with a jeep and car in the middle of the street. These men were able to retrieve an old millstone as a souvenir of their day at the lake. (Courtesy of the Engelbert family.)

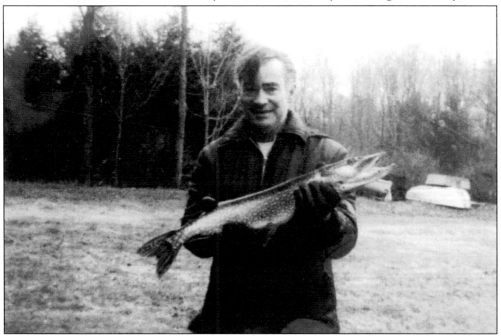

As winter moved in and the waters of the lake turned cold, the icy temperature of the water probably caught this Great Northern Pike unaware. Jerry Centro holds this large fish that he caught by hand. As the fish was returned to the lake, it slowly swam away.

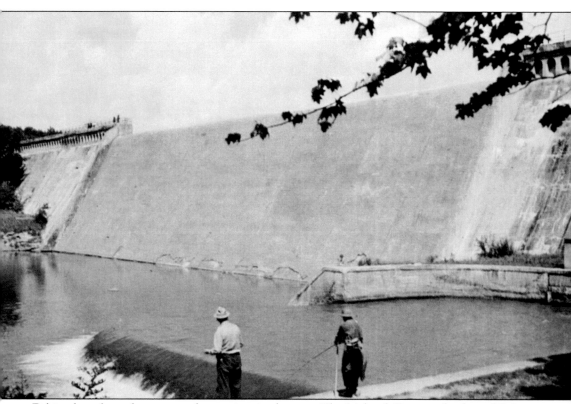

Fishing has always been a popular pastime in the area. The Mohawk River at the foot of Delta Dam has drawn many to fish in its waters. It has been told that many large brown trout lived in the waters close to the dam. Other popular fish caught were bass and pike. After several drownings, access to this area is now limited. At night, the area is lit with large spotlights for safety reasons.

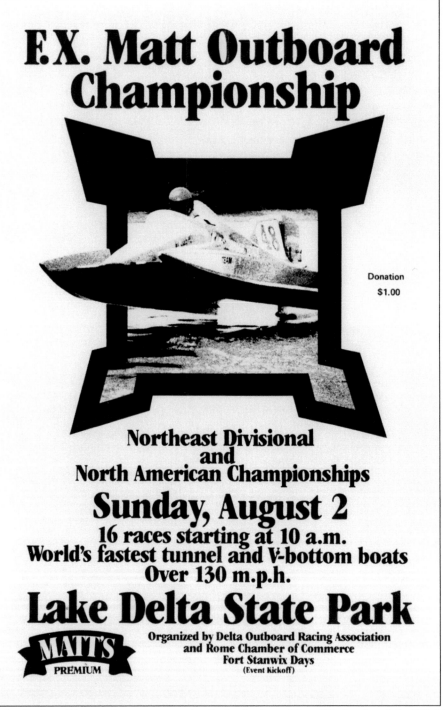

F.X. Matt Outboard Championship

Donation
$1.00

Northeast Divisional and North American Championships

Sunday, August 2

16 races starting at 10 a.m.
World's fastest tunnel and V-bottom boats
Over 130 m.p.h.

Lake Delta State Park

MATT'S
PREMIUM

Organized by Delta Outboard Racing Association
and Rome Chamber of Commerce
Fort Stanwix Days
(Event Kickoff)

The Delta Outboard Racing Association, under the leadership of David Packard, and the F.X. Matt Brewing Company sponsored championship powerboat racing on Delta Lake. In the early 1980s, the world's fastest tunnel and V-bottom boats competed for prize money and titles. It was a fun occasion on the lake, with boats lining the racecourse and onlookers packing the state park.

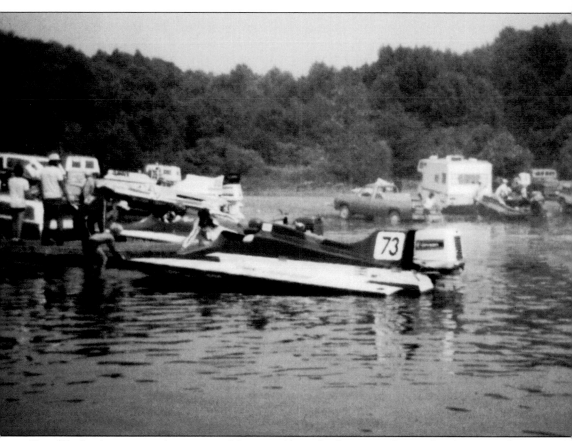

David Packard was a powerboat racer in Hawaii and brought the sport to Rome when he returned to his hometown. The boats participated in a parade in Rome, then were on display at the park before the races. This tunnel hull is being launched and tested at the state park ramp before racing.

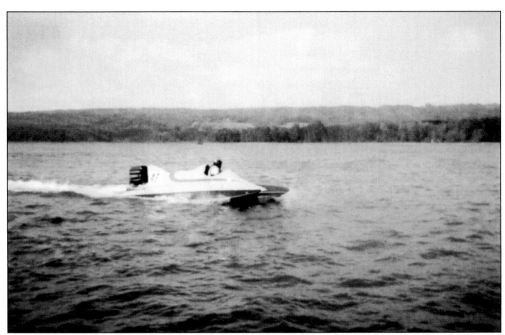

Powerboat racers came from all across the United States to compete on Delta Lake, some as far away as Hawaii. This boat is doing a time trial before the race to judge water conditions and if the motor is running properly. It was a great show with the colorful boats running up and down the lake.

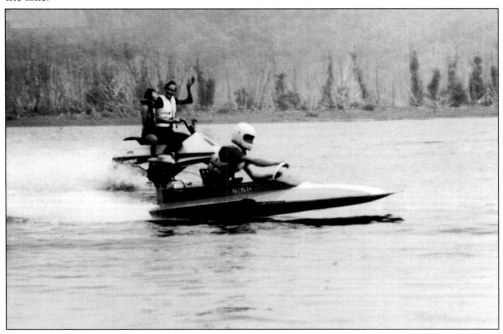

Racing fever spread across the lake with men and teenagers trying their hand at it. Here, Eric Centro Sr. tests the boat that he has just finished building. The seven-foot boat had a 20-horsepower Mercury engine and could reach speeds up to 30 miles per hour. On the Jet Ski is driver Tim Davis and passenger Tommy Gorman. (Courtesy of Eric Centro Sr.)

The state park on the shores of Delta Lake draws individuals from many places. Some campers come from surrounding counties, others come from out-of-state. Maria Murabito of Plattsmouth, Nebraska, came to spend several weeks camping. She proudly displays the Great Northern Pike she caught while fishing on the lake. (Courtesy of Dr. Maria Olberding.)

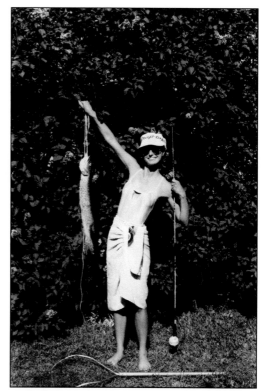

Another frequent visitor to the lake is this American bald eagle, which can be seen riding the air currents. He likes to fish by the dam and often can be seen near the state fish hatchery. This eagle has become the favorite subject for local bird-watchers. (Courtesy of Mike Huchko.)

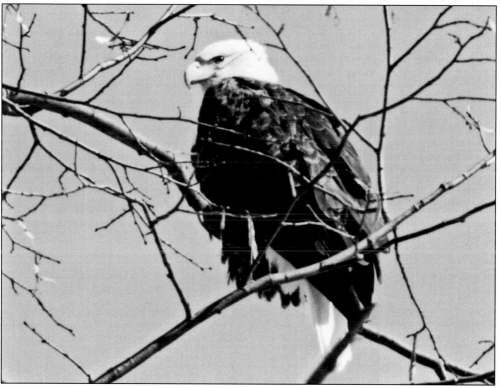

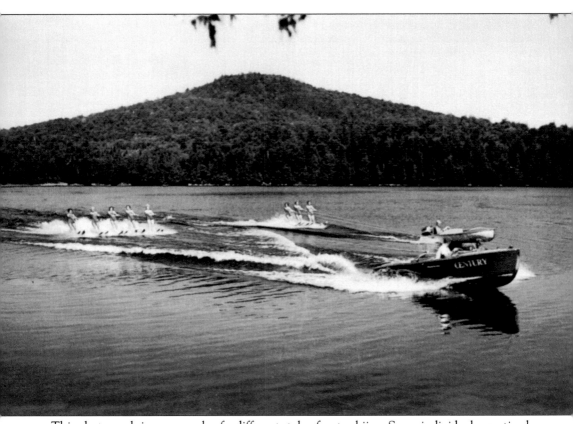

This photograph is an example of a different style of waterskiing. Some individuals practiced on the slalom course in the backsets of the lake, while others learned how to barefoot ski. Today, the interest in waterskiing has fallen off in favor of wakeboarding, a more challenging sport.

The Lake Delta Yacht Club was organized in early 1937, with 90 boating enthusiasts using Dr. H.J. Teller's camp as its headquarters. In the summer of that year, the group purchased property on the southwest shore of the lake. The club's successful first year assured the continuation of yachting as an established sport in this locality.

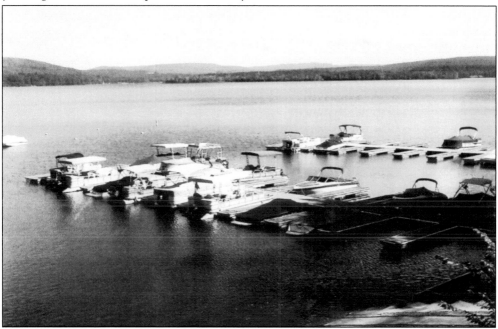

From the original 17 racing sloops and 10 other craft, the number of boats has greatly increased. Finger docks are now available for members to keep their boats in the water all summer. Cleaning and grading of the shoreline provided an adequate swimming area and visitors dock at the yacht club.

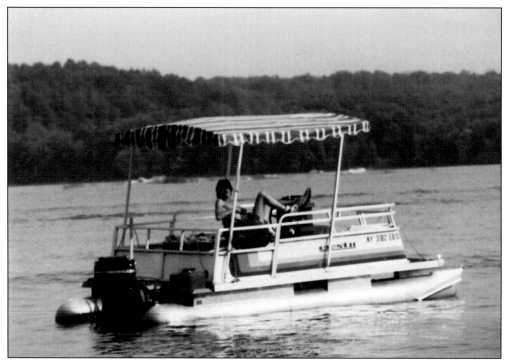

Those lazy, hazy summer days on the lake were a time to play, relax, and just float around. Using the family boat, many teenagers spent their free time on the lake. Jason Centro is seen going out for a leisurely ride in this spiffy pontoon boat.

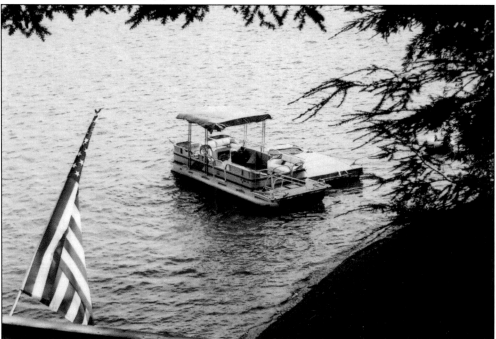

Another pontoon boat is pictured on the lake. The two-seat and four-seat boats, along with speed boats, are becoming rare. This pontoon boat, *Just Add Water*, is waiting to go out.

In the early 1980s, due to a serious dam break downstate, the US Army Corps of Engineers mandated all dams be reinforced. In the mid-1980s, the state started to work on Delta Dam. The front surface was scraped, and new concrete was applied. The expansion joints between the sections were cleaned and re-grouted.

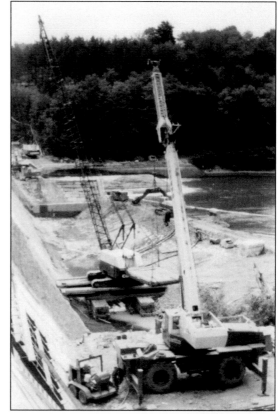

Part of reinforcing the dam required fitting large steel rods into it. Engineers decided the best way was to drill vertical shafts down into the dam to place the rods. The setting of the steel rods was accomplished using a helicopter. After the rods were set, the shafts were sealed with concrete.

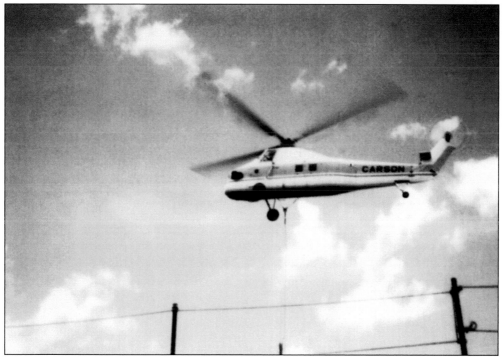

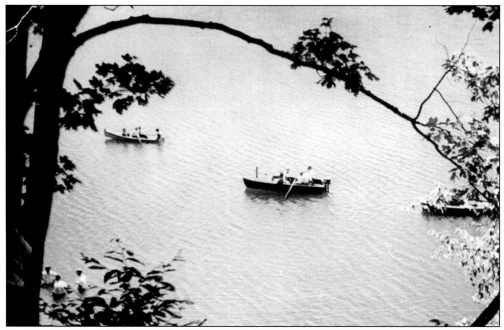

Boating and fishing have always been popular, with many small brooks and streams feeding the lake and creating many good fishing spots. Some people in fancy bass boats slowly troll while others let the current take them. These fishermen appear to having a good time in their Chris Craft boat.

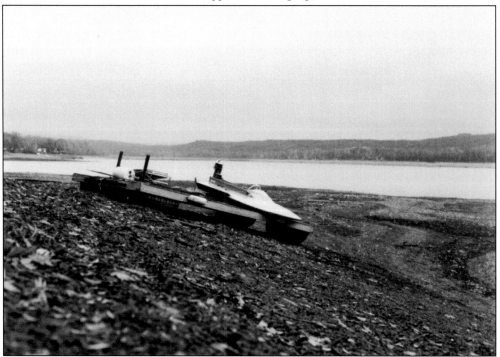

At the end of a hot dry summer, this dock is high and dry along with the yellow hydroplane. The steep shale bank runs down to the river flats and eventually meets the river. This dock will need to be tied up for the winter so it does not float away in the spring.

Winter begins to close in with light snow and a thin layer of ice. By January, the ice is thicker, and people are getting ready to ice fish. In past years, some hardy individuals have tried ice skating in nearby coves.

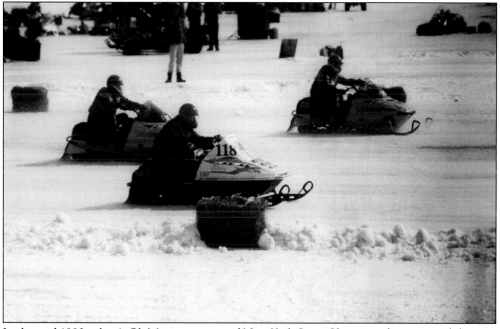

In the mid-1990s, the A-Ok Marina sponsored New York State Championship snowmobile races in front of its facility. Days before the races, the weather had been rainy, but it turned crisp and cool for race day. Racers from all over the state were racing for titles in stock and modified classes plus cash prizes. (Courtesy of Eric Centro Sr.)

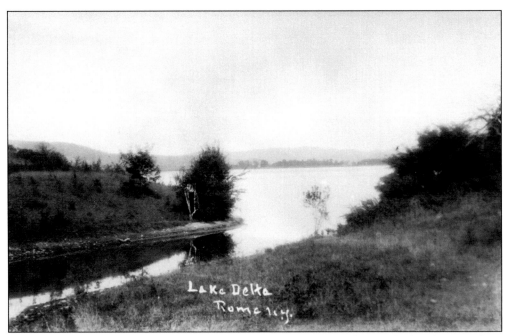

Spears Point was another lovely area on the lake. Frederick B. Hodges took this photograph. It is now a quiet cove with a nice view. Many years ago, a mysterious island was seen nearby in the spring but then disappeared. It is unclear how the point got its name.

Mary June Pillmore, a great bird lover, established a bird sanctuary where the land sloped to the lake at the end of Pillmore Drive. She wrote many articles for the local paper about birds and was awarded many certificates and medals for her work protecting wild birds.

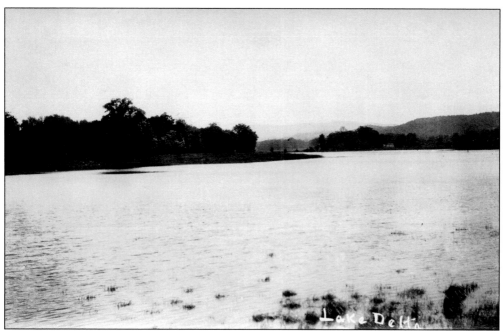

The area where the Mohawk River empties into the lake is called the backsets. It is an excellent place for fishing. One must be careful when boating in this area, for the river washes pieces of logs, tree stumps, and all kinds of debris that are deposited there. When the lake is low, it is a large mudflat.

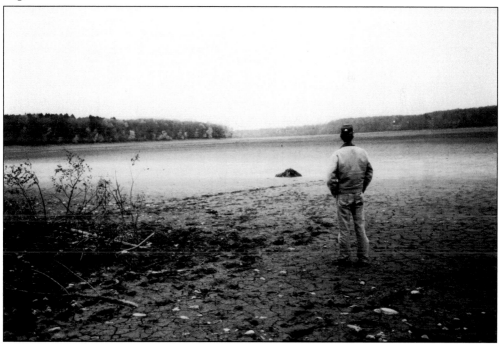

During the dry summer of 1998, the level of the lake was very low. Even the Mohawk River was at a low point. The back sets were covered with sandbars and mudflats. Jason Centro looks out at the dry lakebed, where, in better days, he spent many hours boating.

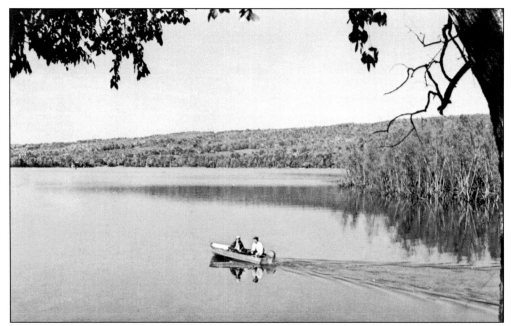

It is a beautiful fall day as two men head out to fish near the mouth of the Mohawk River. The lake is like a mirror reflecting the shoreline in its crystal-blue water. Even when there is a light breeze, the backsets of the lake remain calm. From here, fishermen can go into Hidden Lake and fish in an old channel.

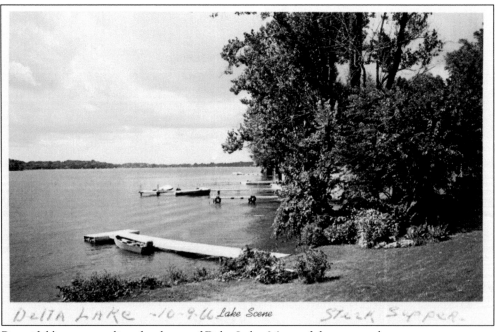

Beautiful homes now line the shores of Delta Lake. Many of them started out as summer camps that were rebuilt into full-time homes. In some locations, lawns sweep down to the lake, and at others, steep stairs descend the hills to the water. It is enjoyable living on the lake.

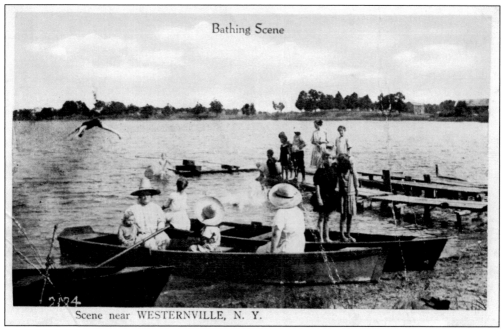

Bathing Scene

Scene near WESTERNVILLE, N. Y.

Outside Westernville on land by the old Wager estate, where the Mohawk River emptied into the lake, a swimming area sprang up. Crude wooden finger docks were built, and a diving raft floated nearby. Some of the onlookers are seated in a rowboat; it is unclear if boat rentals were available.

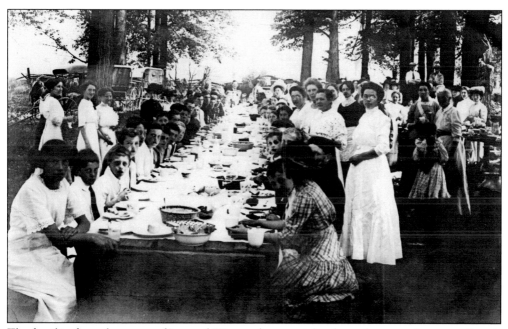

The families from the towns of Lee and Western have socialized together over the years. Church groups have intermingled by attending church picnics, church suppers, and other celebrations. At these functions, friends and family caught up on the latest news.

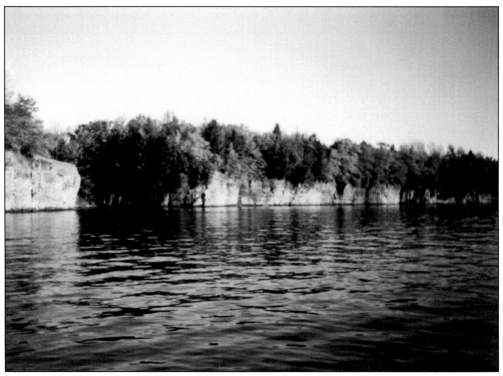

The palisades are still magnificent after all these years. A large part of these cliffs are underwater, but before the dam, they were 200 feet high. Over the years, erosion has changed them somewhat, but these cliffs are still a wonder to behold.

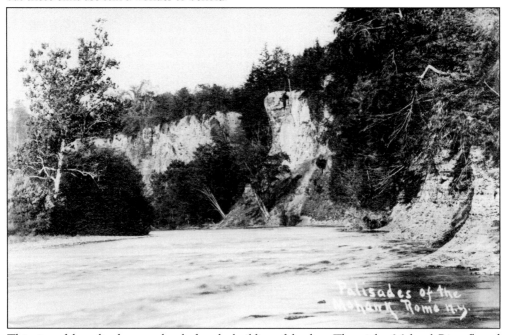

This view of the palisades was taken before the building of the dam. The mighty Mohawk River flowed at the foot of the cliffs. These cliffs were formed by the river's erosion over millions of years.

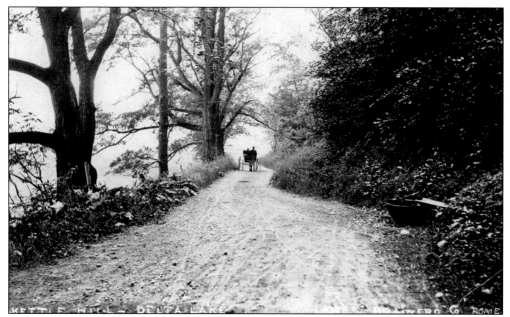

The old River Road ran from Delta along the Mohawk River toward Westernville. In places, the road was steep but went through a glade where William Vincent Evans placed a kettle at a spring that gushed from the hillside. He felt man or beast could use a cool drink before climbing the steep hillside.

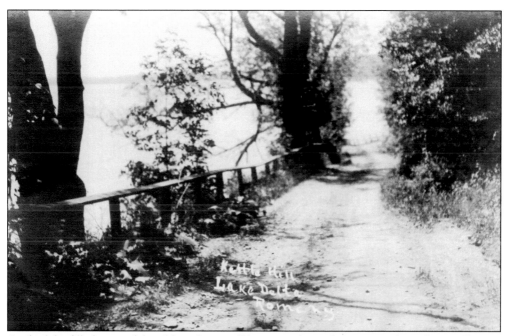

As the lake filled, part of the old road was still being used, winding its way through a small cove. The wood fence still marked the road, which ran directly into the lake. Beside the road, the lake can be seen. As time passed, the road began to deteriorate and became unusable.

On the Henry Wager estate, this island is set in the middle of an area called Hidden Lake. This land and another long narrow strip mark what appears to be a channel dug from the Mohawk River to the nearby canal. The side structures still exist today with trees growing on them. The underwater growth makes this an excellent fishing spot.

In the distance can be seen Delta Lake, which connects the towns of Western and Lee and touches the outside district of Rome. The clear skies highlight the lake, which is nestled in the surrounding hills. While descending Gifford Hill in Westernville, one gets a great view of the lake.

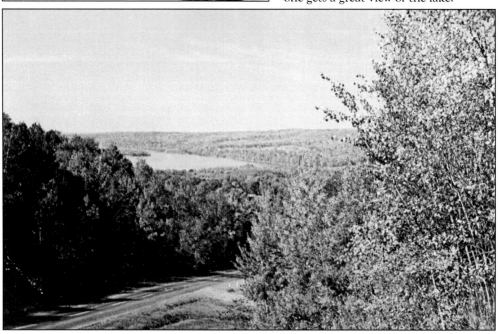

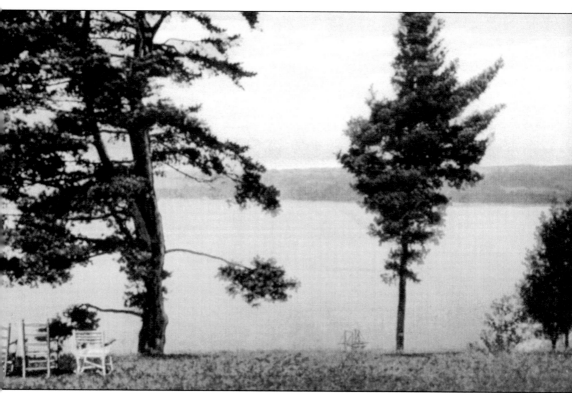

The tour of the towns of Western and Lee is complete. It began in the town of Western and traversed Main Street with its nice homes. Then, the tour continued on to the small hamlets of Frenchville, Hillside, Dunn Brook, Cahootus Hollow, and others that dot the surrounding hills. It went next to the town of Lee and visited the general stores, churches, and small hamlets of West Branch and Point Rock. The tour also explored Stokes reservoir, the Salvation Army camp, and the dam—a modern marvel of its time. Lastly, the story of Delta Lake offered a glimpse into the fun locals and visitors have fishing, boating, and lounging in the sun. The view pictured here connects the townships of Lee and Western as seen from the country club.

Discover Thousands of Local History Books
Featuring Millions of Vintage Images

Arcadia Publishing, the leading local history publisher in the United States, is committed to making history accessible and meaningful through publishing books that celebrate and preserve the heritage of America's people and places.

Find more books like this at
www.arcadiapublishing.com

Search for your hometown history, your old stomping grounds, and even your favorite sports team.

Consistent with our mission to preserve history on a local level, this book was printed in South Carolina on American-made paper and manufactured entirely in the United States. Products carrying the accredited Forest Stewardship Council (FSC) label are printed on 100 percent FSC-certified paper.